Fear Before the Fall

Horror Films in the
Late Soviet Union

Fear Before the Fall

Horror Films in the
Late Soviet Union

Alexander Herbert

Winchester, UK
Washington, USA

JOHN HUNT PUBLISHING

First published by Zero Books, 2023
Zero Books is an imprint of John Hunt Publishing Ltd., No. 3 East St., Alresford,
Hampshire SO24 9EE, UK
office@jhpbooks.com
www.johnhuntpublishing.com
www.zero-books.net

For distributor details and how to order please visit the 'Ordering' section on our website.

ISBN: 978 1 78904 979 4
978 1 78904 980 0 (ebook)
Library of Congress Control Number: 2021947786

A CIP catalogue record for this book is available from the British Library.

Design: Matthew Greenfield

UK: Printed and bound by CPI Group (UK) Ltd, Croydon, CR0 4YY
Printed in North America by CPI GPS partners

We operate a distinctive and ethical publishing philosophy in
all areas of our business, from our global network of authors to
production and worldwide distribution.

Contents

For Evan, Chris, and Andy for encouraging and entertaining my love for horror, and for Sophie, my daily sidekick while writing.

Acknowledgments

This might be the only time someone can actually thank COVID-19. In the spring of 2020, I found out that I had received a Fulbright grant to Russia to research my dissertation, but as the world closed due to the pandemic, I, along with so many other researchers, was stuck at home in quarantine. So, I started watching more movies than usual—not just horror, but all Soviet classics from Mosfilm and Lenfilm, among others. Living through the midst of such a strange historical moment, watching these films really had me thinking about what they meant at their specific time, and I thought it would be fun to use them to talk about life in the late Soviet Union. Then, in the middle of the pandemic, someone very important to me, Professor Robert Bird at the University of Chicago, passed away. I dedicate this book to his memory because in my final months at the University of Chicago, when it was clear that I needed to transfer, Robert took me under his wing as a mentor. Without him, I probably would have given up on academia altogether, but he taught me that I can exist within it and not "belong" to it at the same time, if that makes sense.

This book is not supposed to be an academic monograph. It is for fun, with the crude realization that undergraduate students today, along with leftists interested in the USSR more broadly, are more willing to learn through reading when the content is related to their own interests. No matter how valuable they are, so many academic works are inaccessible to the average working-class reader, which merely perpetuates the stereotype of an "ivory tower." This is not a criticism of my academic colleagues, but a reluctant admittance that in order to stay relevant, I believe we have to present our research and interests in a germane, entertaining way, particularly in the field of Russian and Soviet history. I dedicate this book also to all my comrades who have

worked their entire life and never had a chance to go to college, but nevertheless remain dedicated to learning.

There are also some names to drop here. First and foremost, I want to say thank you to Fedor Lavrov, a constant source of late Soviet cultural knowledge. Aleksandr Mitnikov also helped me translate some scenes from films with particularly bad audio quality. Finally, Evan Andrews, without even knowing it, taught me along the way that film can provide poignant social commentary and provide a mirror on culture in a specific time and space. Thank you to Annabella at the University of Illinois Slavic Reference Service for help finding some valuable resources, and Claire Roosien for reading. This book is also dedicated to these individuals.

Foreword

I grew up in a generation that has matured (or not) with horror. I received my first kiss watching a horror movie, and I like to believe that, if I ever come face to face with a serial killer, I might know how to handle it thanks to horror films like *Scream*, *Child's Play*, and of course *Halloween*. Growing up, my father would take my brother, sister, and I to the local movie rental store to pick out horror films for the weekend. I was probably too young to watch some of them, but they instilled in me a fascination with the genre. What makes people so captivated by witnessing death, blood, gore, and trauma? What accounts for the genre's salience, and how do people think of things like killer pond sludge, unholy books of the dead, and human flies?

Over time I realized that horror movies embody something inherent in our social self. They reflect our deepest fears, anxieties, fantasies, and in some cases our secret wishes in a certain time and place. Those major blockbusters like *Halloween*, *The Shining*, and *Nightmare on Elm Street* are not exclusively forms of entertainment, but their popularity attests to their social relevance. We are eternally afraid of what cannot be understood, what cannot be stopped, and what shifts our sense of possibilities. Think of *The Shining*, for example. We watch that film with a sense of uneasiness because, while we understand the logistics of Jack Torrance's existence across time, we can completely believe the idea that, given isolation and the pressures of a demanding career and family, anyone can snap. It cannot be a coincidence that this story appeared in the same year as the New Mexico State Penitentiary Riot, the re-introduction of the peacetime military draft, and the nomination of Ronald Reagan.

In the late 1970s and throughout the 1980s, production of horror movies from independent filmmakers and Hollywood exploded. It was a time of intense Cold War conflict (*Toxic*

Avenger?) and a resurgence of conservative ideals. The space race was in full swing, which goes a long way to explaining the proliferation of extra-terrestrials into the pantheon of horror monsters. Along with the rise of horror, hardcore punk came to the scene, giving disgruntled youth an outlet to express their ideas in a safe space full of like-minded people. It's not difficult to imagine that the ascent of horror occurred in conjunction with an increasingly scary and alienated world (at least for everyone in the working class). Horror reflected and partially satirized those freights in the form of nuclear holocausts, toxic waste pollution, alien clown invaders, and undead houseguests. Everyone was at risk—teenagers especially—because their world was the most uncertain and out of their control.

As I started to study late Soviet history, I began to wonder whether the Soviet Union confronted a similar phenomenon. A quick look on Mosfilm's YouTube channel brought up the topic of Chapter 1, a cinematic rendition of Nikolai Gogol's *Vii*, a haunting tale of adolescent overindulgence, irresponsibility, and fate. Released in 1967, the film stands out among Mosfilm's catalog if only because it is the oldest of its kind. Indeed, even compared to Western horror films of that time, *Vii* is quite haunting. The classic rural witch and the pale white maiden are nightmarishly depicted, leading to the ghoulish conclusion where the creature, *Vii*, finally ascends from hell. I was surprised to learn that *Vii* was and is considered still the first Soviet horror film, even though its screen writer (Aleksandr Ptushko) was more famous for his folkloric depictions and fantasies.

As entertaining as *Vii* is, it occurred to me that it was as much a reflection of its time as its American counterparts. In fact, the more Soviet horror films I discovered and watched, the more I started to realize that they all reflect different aspects of late Soviet politics, society, and culture. I wondered whether one might be able to isolate these films and use them to reflect on what was in the air at the time. Hence, the driving question of

this book: what does horror tell us about life in the final decades of the Soviet Union?

Introduction

The point of this introduction is to present the conceptual goals of this book, and to contextualize what I believe the following chapters seek to accomplish collectively. To put it simply, in order to account for the emergence of horror films in the last decade of the USSR, we have to first create a conceptual map of what makes horror, horror. Rather than regurgitating every academic theory on the genre, I provide a few relevant interpretations to get us started. The citations included are meant to encourage the reader to do their own research into a particular theoretical framework that piques their interest. The next goal is to describe the specifics of Soviet cinema by providing a brief overview of its history and limitations leading up to the late 1980s, when horror finally broke through stringent censorship. Because early Soviet directors were so innovative and integral to the history of the moving image, this is a widely researched and written about topic, so I don't find it necessary here to cite every article and book but rather to synthesize some broader take-aways. Only then can we begin the project of understanding what horror meant in this place at specific times.

There is a basic paradox underlying this book, the classic chicken-or-egg quagmire. On the one hand, it argues that social anxieties and fears in the USSR gave rise to new ventures into the horror genre that pushed the boundaries of permissibility in *perestroika* pop-culture. That suggests that social transformations imposed from above—politics— preceded cultural expression. On the other hand, the pattern of Soviet horror moved in a perpetual circle, as one film came out, new directors wanted to test the genre as an opportunity to convey new themes with old stories. In good Marxist fashion, and understanding the monumentalism of *perestroika*, one is inclined to admit that these films were not possible without

political and economic reform. At the same time, the themes highlighted in each chapter existed in embryo before 1986, discussed in private homes and foreign and samizdat journals, throughout the post-Stalin period. In other words, *glasnost* and *perestroika* made horror in Soviet cinema possible, but they did not create the anxieties felt by Soviet denizens. This book's aim is to demonstrate the relationship between society and culture, to argue that Soviet horror films exploited the deep-seated insecurities of late Soviet people.

Horror

There's a scene in the 1987 film *Gospodin oformitel'* [Mister Designer] (Chapter 3) where the main character, a sort-of 1920s Dr Frankenstein, confronts the living mannequin he created and asks why his "thing" (referring to her) came to life and killed her lover. She responds to him in pale white makeup, ruby red lipstick and cold expression, with a demonic voice track layered over the actress's natural voice, that it was not her, but him who killed the man. He retorts, "Remember your life in the shop and you will never be a match for the mortal whose rights you have assumed." In frustration he strikes her with a flaming log, and the camera shows part of her face melted off from the flame, but before he can finish her off another character shoots him down. The story is about man trying to act like God by committing himself to creating the most perfect, life-like shop mannequin, taking his crusade so far as to create an uncontrollable creature that is neither living nor dead.

The scene captures so much of what many scholars have already said about horror films. Horror films resonate with people precisely because they transcend our sense of what is rational, and they challenge our expectations of what is possible. For example, the idea of a mannequin coming to life among the living is not only fantastical, but it taps into something fundamental in the human psyche—that feeling we

cannot express every time we see a store dummy or Halloween yard decoration that looks a little too realistic. There is a sense of powerlessness over the idea of something we created supplanting us as individuals or as a species, which is why we're all frightened of robots turning against us, or the idea of run-away climate change. Of course, there's also no coincidence that the designer crafts a mannequin in female form, a reference to man's never-ending quest to confine and control the female figure, lest it acts with impunity.[1] (This is not just a contemporary political reality, but an old cinematographic trope; for example, the 1913 American film *The Vampire* by Robert Vignola is the story of a woman who ruins the protagonist's otherwise happy life). That fear of losing control and confronting the unknown are some of the fundamental elements that define horror. The film genre exploits those fears by proposing that our sense of what is "normal" is but a ruse, upsetting the binaries that we take for granted like life and death, the sacred and the profane, and sane and insane. Horror taps into and drives a wedge between our collective knowledge of life's unmovable realities, and our psychological insecurities.[2]

Scholars tend to think of horror in several different but related ways. Referring to the gothic narratives of the nineteenth century, one scholar argues that they convey a sense of insecurity in our knowledge over good and evil, so narratives frequently move between "outcast individuals and the social conventions that produced or constricted them."[3] Such a reading is certainly the case in films like *P'iushchie krov'* [Bloodsuckers] (Chapter 6), where high society women act as a metaphor for vampires. This leads us to the allegorical understanding of horror, where ghosts, vampires, werewolves, and ghouls represent particular groups of "others," be it bourgeois society, BIPOC, women, homosexuals, or even children.[4] Basically, anyone who deviates from cis white working-class male heteronormativity has been represented in one shape or form as a monster. As we will see

in this book, there's no limit to who or what might be depicted as ghoulish in late Soviet horror films, from young women to grandparents, children, and ourselves.

Paul Well identifies a number of conditions that underpin contemporary horror texts that can be seen in late Soviet horror. These include "social alienation, the collapse of spiritual and moral order, a deep crisis of evolutionary identity, the overt articulation of humankind's inner-most imperatives, and the need to express the implications of human existence in an appropriate aesthetic."[5] Such topics resonate with audiences, which is what helps maintain horror's position as one of the oldest and most continuously evolving mediums. It also explains in part why the heroes of most horror films are working-class people; creators need to pander to their audiences' sensibilities and lived experiences. Because the genre deals with how we want to (or don't want to) understand our alienated selves, early cinematographers realized its ability to reflect on social and cultural topics right away. Hence, Georges Méliès, one of the first practitioners of the genre, made *The Haunted Castle* in 1896, and in 1915 Evgenii Bauer put out *Grezy* [Daydreams], which depicted the resurrection of the protagonist's dead wife. Right up to 1917, Russian cinema engaged with horror narratives, as depicted in famed director Yakov Protazonov's 1917 *Satana Likuiushchii* [Satan Triumphant].

These titles, coming as they do around and within World War One, speak to the point that horror tends to emerge and re-emerge around times of social upheaval and revolution. Morris Dickstein and S.S. Prawer argue precisely this point that social crisis lends itself to popular horror because audiences are vulnerable and open to having their sense of what's possible in the profane world challanged.[6] When our living reality is frightening enough, horror takes it a step further to show us the worst possible version. Cyndy Hendershot's *I Was a Cold War Monster*, which might be read as a compendium to this book,

highlights how and why horror became such a popular genre in the Cold War United States and Britain by playing on the audience's fears of communism and nuclear holocaust.[7] There is a masochistic, Freudian impulse within the human psyche that enjoys watching our narrative expectations be violated by monsters and inexplicable events. For example, I am frightened of snakes—one of the fundamental fears listed by Stephen King—but that doesn't stop me from watching YouTube videos of snakes doing snake things.[8] As Kendall Phillips explains, watching what promises to frighten us forces us to "think differently about [our] anxieties, or at the very least, to think about our normal patterns of dealing with those anxieties." He proposes the phrase "resonance violation" to describe the double process that the genre achieves of resonating with a particular audience through the act of violating their sense of what is permissible and normal.[9] The key point worth emphasizing and remembering, at least for readers of this book, is that audiences enjoy this violation—it keeps us coming back for more, as though we enjoy watching our greatest fears unravel.

However, horror looks different depending on where you are in the world, and what time it is. Sure, the cinematographic techniques have become convention (jump scares; pale white makeup; wide eyes; floating phantoms; suspenseful, building music), but the meaning of ghouls and goblins resonates with audiences to different degrees in different cultures. Culture is fundamental to my understanding of horror, and I define it in a similar way as anthropologist Clifford Geertz. Referring to Max Weber, Geertz famously said, "man is an animal suspended in webs of significance he himself has spun, I take culture to be those webs, and the analysis of it to be therefore not experimental science in search of law but an interpretive one in search of meaning."[10] Following that line, I interpret what is depicted (or not depicted) in horror films to be one of the most essential elements to understanding a country's culture. We

cannot understand the late USSR in its totality through these horror films alone, but we can gain a sense of the anxieties and fears that resonated with viewers.

Whether the genre is interpreted through a psychological-cum-Freudian lens, its fixation with body mutilation and excess, or even its willingness to destroy our sense of orthodox domestic space, horror, more than any other genre, strikes at the heart of our fears as humans. Therefore, so much of the genre, if not all of the genre, has to do with death and dying. It's almost not enough to say that fear of the unknown defines horror, because death itself is more than unknown—it's a universal reminder that life is ephemeral. Hence, I define horror film as that which uses images of death, the macabre, and alienation to violate our everyday normality, in which the directors make a concerted effort to exploit the audience's fears as a form of shock therapy, offering us an alternative reality. This of course requires the directors to be involved in some way or another with creating entertainment for mass appeal, an element that is important to keep in mind when considering the emergence of horror during *perestroika*. In late Soviet horror, we will see a variety of narratives and cinematographic approaches to capturing and conveying terror. Like the scene in *Gospodin oformitel'*, sometimes we create pieces of art that reveal more about ourselves than we intended.

Before moving onto Soviet cinema more broadly, I should take the time here to briefly account for what I did not include in this book and try to defend my decision. In particular, I omitted the phenomenon of necrorealism. Many scholars have written on Evgenii Iufit's films and aesthetic, and while I think its obsession with life and death, social provocation, and the absurd intersect with horror, the films did not concentrate on conveying a sense of terror.[11] Iufit and the crew involved in *Papa, Umer Ded Moroz* [Papa, Father Frost is Dead, 1991] sought to depict death "as a process."[12] Hence, necrorealism is a morbid extension of socialist

realism, a broader artistic trend in the USSR that showcased life as it is every day for the worker. The fact that Iufit displayed death as a process does not violate our sense of normativity as much as it forces us to confront it, reinforcing it in such a way as to make it absurd. Furthermore, the technical aesthetic omits the conventions of horror cinematography—no jump scares, anticipating music, or even paranormal activity—just a realistic obsession with death-as-process. In that sense I can be critiqued for imposing a Western definition of horror film on a non-Western country, but as mentioned above, pre-revolutionary Russia was actually at the forefront of inventing the genre as we popularly know it—as it came to be recognized in the West.

Brief History of Soviet Cinema

The Soviet Union transformed the nature of cinema not just because it nationalized the film industry, but because it gave young directors the opportunity to fashion a tradition for a socialist future. In fact, leading up to World War One, Russian film was largely bank rolled by Western financiers, who were eager to invest in the tsarist empire. During the war, officers and the aristocracy recognized cinema's potential value as propaganda and entertainment for soldiers, so while many might assume that state-directed film emerged only after Lenin's nationalization of the industry, there are signs of the process emerging before October 1917.[13] Nevertheless, when the revolution did come, many of Russia's old-guard actors and directors fled Petrograd for Odessa or Paris, afraid of their status as the cultural bourgeoise.[14] This simultaneously shocked the industry and bankrupted it, paving the way for innovative figures to define the new socialist aesthetic and chart a new course for the moving image.

Lenin and the Bolsheviks expressed their awareness of cinema's importance for the new regime almost immediately and sought to use it for financial and ideological purposes.

As early as November 9, 1917 they established the State Commission on Education (Narkompros) headed by Anatoly Lunacharskii, with a film sub-section supervised by Lenin's wife and contemporary, Nadezhda Krupskaya. But because the revolution forced many to flee, the new state lacked the technical and artistic workforce necessary to jumpstart its new industry. Then, in August 1919, Lenin nationalized the film industry, turning full authority of it over to Narkompros in the interest of creating new educational motion pictures. That centralization was slightly relaxed under Lenin's New Economic Policy, which some dub as a turning point for Soviet cinema. A revisionist opinion states that rather than slowing the growth of the film industry in the USSR, the nationalization decree was an attempt to leverage the power of film to bolster the fledging economy.[15] This meant that filmmakers could turn a profit from their films, and production and distribution became self-supporting as a way of inspiring initiative among production houses and crews. Commissariat of Nationalities, Joseph Stalin, also promoted the creation of national film-studios to help foster autonomy within the numerous republics of the Soviet Union.

Lenin envisioned the film industry as a valuable resource to promote class consciousness and worker solidarity in support of the new regime and communist ideology, famously stating that "the cinema is for us the most important of all the arts." In that sense, his vision was entirely utilitarian. Foreign imports and new entertainment films were meant to raise revenue, and other genres were to include depictions of people from all countries in order to inculcate the Soviet people with a sense of internationalism.[16] In truth NEP's loose restrictions on film served as a stopgap measure to help the state, and once that goal was satisfied, in the final years of NEP, Narkompros gradually tightened control. Hence, between 1924 and 1926 the nationalization process narrowed the technical and artistic possibilities of Soviet film. Directors like Dziga Vertov, Lev

Kuleshov, Iakov Protazonov, and Sergei Eisenstein experimented extensively with novel camera angles, screenplays, editing, and montage, representing a willingness to innovate a new form of cinema to accompany the new society.

Throughout this period and beyond, Soviet cinematographers did not explicitly create horror films. One reason is that Lunacharskii, as head of Narkompros, advocated for melodrama as an art form to combine propaganda with entertainment for the people.[17] Even though he co-authored the 1925 film *Medvezh'ia Svad'ba* [The Bear's Wedding], broadly categorized as horror, its plot and techniques borrowed from pre-revolutionary cinema more than offering something new, and the horror aspect was dialed down. Another reason was simply ideological: toward the end of NEP, and particularly in Stalin's early years, major film makers perceived horror as overly fixated on personal psychology and ignorant of class and social issues. The superstitions and promotion of the paranormal not only pushed against the Soviet stress on atheism, but also promoted reactionary ideas that denigrated the effort to construct a new, future-oriented, socialist society built on realism.[18] A vampire's aversion to the cross meant nothing in a society that did not *officially* believe in sanctity.

From the late 1920s to the early 1950s, a period aligning with Stalin's leadership, the state reigned in the film industry and gradually and decisively reduced the importation of foreign films. By rebuilding the economy, NEP did what it set out to do, and now the task of the Party was to pave the way for an altogether new style of film production and consumption that focused on realist themes of duty, heroism, and patriotism. American films were critiqued for their promotion of bourgeois values and imperialism coincidentally at a time when Hollywood horror classics like *Dracula* (1931) and *White Zombie* (1932) started to appear in theaters. Only World War Two relaxed the censorship of Western films, albeit for just a short period of time in order

to promote the alliance of allied powers. Overall, between the centralization of the industry in 1930 and Stalin's death in 1953, the ideological straight jacket tightened, and Soviet studios had to produce "thematic plans" for every movie. Rather than prohibiting deep analysis of Soviet society at this time, the existance of censorship allows us to glean a lot about what the Party wanted to promote as social and cultural values, as well as ethnic stereotypes and everyday experiences.[19] Solidarity, internationalism, and patriotism all defined the cultural tropes of post-war cinema. The fact that horror did not really exist in this period speaks more to the genre's salience as a medium that depends on emotions and unreality, and because it deals with death and the paranormal, Soviet cultural authorities had little use for it as socialist propaganda. In 1970, the Kinoslovar defined horror as "leading away from the real problems of reality, generating moods of hopelessness and fear, contributing to the emergence of cruelty."[20]

With Khrushchev's de-Stalinization campaign, some restrictions on film were lifted, if even temporarily, and a new generation of filmmakers emerged. Many histories of Soviet film tend to divide periods according to Party leaders, but the fact is that from 1956 to 1985, Soviet film churned out a plethora of movies of various genres from comedy, historical drama, melodrama, and folktales. Beginning in the final years of Stalin's life, filmmakers sent signals to the authorities to increase the volume of film production and improve equipment, which required more flexibility in what could be depicted. Only after Stalin's death did the industry renew their calls for change, sending an appeal to Khrushchev and the Minister of Culture on April 14, 1953.[21] Even though approved content increased, the twofold control of Soviet cinema between the State and the Party persisted throughout the 60s and 70s, particularly in the Central Committee of the Communist Party.[22] Cinema at this time reverted to a type of symbolic formalism uncharacteristic

of the socialist realism of Stalin's time. Directors like Andrei Tarkovskii (*Solaris* 1972, *Stalker* 1979) appealed to the Soviet public by introducing novel topics that dealt with human emotion and morality in an artistic and thought-provoking way, playing on images and sounds of water, earth's lifeblood. Tarkovskii's use of science fiction and the inexplicable has led some film scholars to at least draw a line between films like *Solaris* and *perestroika*-era horror.[23]

As we will see in Chapter 1, the rise of consumerism in the late 1960s and 70s gave more credence to commercial considerations over rigid ideological orthodoxy. The ninth five-year plan of 1971-1975 demonstrated the economic failings of the country, and the State Committee for Cinematography sought to exploit the new consumer culture to raise money. Part of that strategy involved importing foreign films, giving domestic producers competition and improving the creative output of Soviet films. Even still, some pictures were restricted from full publication only to be released during *perestroika* or after.

What makes the period of *glasnost* and *perestroika* so integral to the history of Soviet cinema, and yet so paradoxical, is that it saw initiative for industry change emanate from the CPSU, rather than from the industry itself. Granted, members of the film industry sought and lobbied for changes well before *perestroika* but change only came when the regime considered it integral to its restructuring campaign. The process of decentralization, initiated under Gorbachev's leadership, released pressure from decades of suppressed creative talent and ideological restriction. Films that struggled to make waves before *perestroika*, like surrealist films and those seriously addressing youth issues, finally broke through after 1986. In May of that year, at the 5th Congress of the Filmmakers Union, three-quarters of the leadership were replaced by progressive members not promoted simply by Party bureaucrats. When the controversial director Elem Klimov became head of the union,

replacing the repressive Lev Kulidzhanov, who led from 1965-1986, spectators hailed it as a triumph, even though the decision was still heavily influenced from above. Major studios like Lenfilm also sought to reinvigorate the studio with artists and directors to encourage personal initiative in creating innovative motion pictures, which, as we will see with *P'iushchie krov'*, it managed to do.[24] This new progressive leadership paved the way for the diversification of the Soviet film catalog, opening the possibility for genuine horror films. As one film commentator at the time noted "the [horror] genre has become fashionable because irrationalism has become fashionable."[25]

Two concluding points are worth stressing. One, horror films are perhaps the most capable of demonstrating the power of the moving imagine in that they intentionally manipulate the emotions and experiences of the viewer by toying with something psychologically conservative in human nature. Two, for a number of reasons—mostly ideological but also technical and social—the Soviet Union did not consciously produce horror films before *perestroika*. These two theses suggest an attempt on the part of Soviet cultural authorities to quell the creative impulse to depict death and the macabre. In a society ideologically devoted to the supremacy of rationalism, horror had no place because it threatened to leave workers unsure of their status as fully cognitive, future-oriented beings. Hence, apart from *Vii*, all of the films discussed in this book retain their rationalism, or at least an immediate association to the lived reality of Soviet people. Whether by its unveiling of fake phantoms, or the finale that suggests everything was but a dream, horror, even during *perestroika*, failed to leave the macabre inexplicable. Horror came to the Soviet people only really after 1986, but they definitely made it their own.

Chapter Roadmap

The chapters are organized uniformly for ease of reading and

reference beginning with a brief introduction, followed by a narrative summary, broader discussion of context, and an analysis of the film. Most of these films are based on short stories, and in that case I thought it necessary to explore the original story in order to highlight where the film deviates. In many ways, much of the film analysis rests on the idea that what is omitted or added from the original story reveals a lot about what screen writers and directors thought resonated with audiences. Without getting into it in every chapter, suffice it to say that each story that a film is based on existed in its own historical time and place.

Chapter 1 explores what is commonly referred to as the first horror film in the USSR, *Vii*, a collaboration between some of the best minds in Soviet cinema and two novice directors, Gregory Kropachev and Konstantin Ershov. Originally a short story from Ukrainian author Nikolai Gogol, *Vii's* adaptation to the big screen signaled a change in Soviet perceptions of consumption and communist consumer ethics. Chapter 2 deals with the touchy subject of national reconning with the horror of Stalin's terror through the lens of Valerii Rubinchik's 1979 Belarus film *Dikaia okhota korolia stakha* [King Stakh's Wild Hunt]. Chapter 3 is about *Gospodin Oformitel*, a spiritual tale based on the futurist short story by Aleksandr Grin "The Grey Automobile." In many ways this story stands out the most because it is neither horror in the visual sense, nor in the production sense. Instead, it deals with the consequences of supplanting God, and the essence of *things*. Chapter 4 shifts focus once again out of Russia for the 1987 Uzbekfilm *Vel'd* by Nazim Tuliakhozhaev, an adaptation of a Ray Bradbury story "The Veldt." This film gives us an opportunity to peer into some of the generational and environmental issues prevalent in 1986, after the Chernobyl nuclear disaster. In some ways the final two chapters are the most familiar horror tales to Western audiences, and they relate to each other the most in that they are both

vampire stories. Gennadiy Klimov and Igor Shavlak's 1990 film *Sem'ia vurdalakov* [Vampire Family] and Evgenii Tatarskii's 1991 *P'iushchie krov'* [Bloodsuckers] are both adaptations of Aleksei Tolstoi stories, and they both use the image of vampires as a metaphor for social commentary. The conclusion examines two werewolf stories to extend the metaphor of "transformation," explaining why lycanthropy makes an appearance in the final year of the USSR.

The films that I choose do not represent the entirety of late Soviet horror, and they definitely reflect my own personal bias, but they are nevertheless broad in geographic scope and representative of the genre's struggle to emerge at the time, and I believe they are the most revealing and entertaining for English-language readers of this book and horror enthusiasts more broadly. Throughout the book, I provided the Russian transliteration of horror films for easy reference, but only the translated title of non-horror films. I rendered Russian names according to the Library of Congress transliteration system and transliterated non-Russian names from the Russian spelling.

Chapter 1

Generation of Superfluous Consumers: *Vii* (1967) as Precursor to the Genre

"Vii—a colossal creation of the imagination of simple folk. The tale itself is a purely popular legend. And I tell it without change, in all its simplicity, exactly how I heard it told to me."

Chiding personal association with the tale, Gogol's short story opens with this statement that claims that *Vii* is not a fantastical tale conjured from his own mind. By stating that, Gogol claimed to be acting as a reporter or sorts, recording a folktale as told to him, with the occasional embellishment. In his time, such literary techniques were useful for avoiding censorship and maintaining the ability to convey complex social and moral messages without taking the heat. The same can be said for directors Gregory Kropachev and Konstantin Ershov's *Vii* (1967), where they depicted the supernatural consequences of overindulgence and moral degeneration through the forces of evil.

The truth is that despite what some contemporary critics of the film suggest, Aleksandr Ptushko's re-writing of the story, and Kropachev and Ershov's depiction of it on the big screen, does not deviate much from Gogol's original. Sometimes the two pair so seamlessly that lines and facial expressions are pulled right from the novella. However, as this chapter argues, the directors emphasized certain aspects of the main character in order to pass a subtle comment about the changing nature of consumption in the post-Khrushchev USSR. If Gogol's original story played with the image of the "superfluous man," a *Hero of Our Time* whose vanity was made possible by the sacrifices of the father, then it makes sense that the story would re-surface in the 1960s, after the trauma of Stalinism and World War Two that paved the way for a new "superfluous" generation.

The Narrative

Vii is the tale of a seminarian (an aspiring philosopher), Khoma Brute, who encounters a witch in the form of an old woman who lives alone in the countryside. As he desperately liberates himself from her spell, he beats her to death, but not before she transforms from a haggard old woman to a beautiful fair-skinned maiden, Pannochka. A few days later, the father of the maiden summons Khoma to his village to spend the next 3 nights locked alone in a church with the young woman's body, where he is to read biblical passages to help her soul pass. The father has no idea that Khoma is responsible for his daughter's death, he only knows that her dying request was to summon Khoma Brute, the young seminarian. Khoma, of course, does not have the strength to tell the father the truth about his bewitched daughter, and instead feigns any association. On the first night, Khoma witnesses the dead witch rise from her coffin and attempt to find him in the church, but it is clear that the corpse is blind and cannot see past the imaginary cylinder Khoma has drawn around himself with chalk. The rooster crows and the witch retreats to her bed, ending the first night of Khoma's torment. Lacking sleep, Khoma continues to try to escape his Cossack-enforced prison, but he is guarded by the watchful eyes of the father's henchmen—a group of hearty old men with long mustaches and khokhol—the traditional Cossack hairstyle—who question the philosopher's knowledge, but also feel a bit of pity for him.

On the second night Khoma draws his circle and begins to read again. This time the casket literally rises from its pedestal, and it bashes the invisible cylinder in the air like a battering ram. Still, though, the witch can't break through, but that doesn't stop her from shattering Khoma's spirit entirely. After the second night, Khoma's hair turns ghostly white and, totally deprived of sleep, he begins to show signs of losing his sanity. He tries to appeal to the father to allow him to leave,

but the father threatens a severe lashing if he doesn't fulfill his daughter's last wish. As a reward, he offers Khoma 1000 gold pieces for a finished task, which Khoma uses to pad his confidence for the third night.

In the final night, Khoma draws his circle and begins to read. The witch rises and tries once again in vain to locate him. She summons all sorts of beasts and vampires from the ceiling and floorboards to crawl out and help in her search, but none of the beasts can see Khoma. Finally, the witch summons Vii, and the giant's footsteps are heard entering the church. An amorphous monster with closed eyes comes before Khoma, and the witch goads Vii to locate the horrified young man. Vii tells the other monsters "open my eyelids, I cannot see!" Khoma recognizes, like Lot in the story of Sodom, that if he looks Vii in the eye, the monster will see through his invisible shield and expose him. Like Lot's wife, Khoma eventually looks at Vii, communicating to the reader that Khoma was unworthy to be saved because he could not show any refrain. In the original story Khoma drops dead from fear, but in the film the monsters pounce on him and ostensibly kill him (although it's not entirely clear).

In the story, Gogol emphasizes that Khoma is a rather cheerful character who enjoys smoking his pipe, drinking wine, and dancing the tropak. When he is punished with the lash, he shows no remorse and claims, echoing the sentiment of Mikhail Lermontov's antihero in *A Hero of Our Time*, that "a man cannot escape his destiny."

Gogol's Khoma and Lermontov's Pechorin, like Aleksandr Pushkin's Eugene Onegeon, embody a specific archetype of early nineteenth century Russian literature. Having been raised in a position of privilege, these men do not realize how good they have it, but merely relish in the accomplishments of their fathers' generation, the "great men" who pushed back Napoleon and initiated the Decembrist uprising. Khoma is just as unmindful and prone to vices as his literary doppelgangers,

although his fate is a bit more fortuitous.

Rather than address his failings and sins, Khoma casts them all to fate, excusing himself from spiritual labor and failing to take responsibility for his actions. Along with the theme of temptation, Gogol's story has several related narrative threads, the most significant being the dangerous naivety of seminarians when they profane the spiritual world. Every time Khoma sarcastically incurs the wrath of heaven, something atrocious happens to him that leads to his ending. For example, when he first encounters the old woman, he exclaims "Put us up where you like, and if we eat up all your provisions, or do any other damage, may our hands wither up, and all the punishment of heaven light on us!" We know the course of his night after that — he proceeds to beg for food and is punished by the witch. In another passage, Khoma is asked by the young woman's father why the maiden chose him out of anyone else to read prayers over her grave. Khoma denies any knowledge of her, and instead states "it is a well-known fact that grand people often demand things which the most learned man cannot comprehend…May the lightning strike me on the spot if I lie." Hence, Gogol's point in the story was to poke fun at seminarians, particularly philosophers, who doubted the existence of heaven and hell. That partially explains why Khoma is so willing to invoke heaven's wrath, and as we see the consequences unravel to his immanent punishment.

The Context

It is interesting that this story, which had been around since 1835, was adapted for film in the second half of the 1960s. Up to that point, the Soviet Union had not released any horror-like films, overwhelmingly preferring drama, biopics, historical fiction, and occasionally fantasy and sci-fi, as discussed in the introduction. But underlying the horror and folklore of it all, the story uses the image of Khoma as a commentary on the naivety

of novice students. Despite the freshness of their knowledge, they fall victim to certain temptations and deny the validity of superstitions that cannot be reasoned away by philosophy. In the story, there is a scene where the old Cossack men tell Khoma the tale of Mitka and Cheptoun, two lowly villagers who encountered the witch firsthand. In the case of Mitka, he is a spectacular marksman and hunter who demonstrated no appreciation for the skills given to him and the animals delivered before his gun. Cheptoun, on the other hand, was a known village thief and liar. Thus, one of the major themes of *Vii* is the condemnation incurred from overindulgence and ungraciousness, a character trait that dooms an individual to subservience to the forces of evil.

By the time the film went into production, Khrushchev had been ousted by Brezhnev, who seemed at first to lead a collective-leadership government between Party and State. It's said that in the early years of his tenure as General Secretary, Brezhnev was at least open to criticism and new ideas, unlike Khrushchev who pushed projects like the Virgin Lands campaign despite his lack of communication with credible agricultural experts, and his overall distain for criticism. In the late 1950s and early 60s, Khrushchev also promised a lot in terms of "goods for popular consumption," as evidenced by the "Kitchen Table Debates" with United States' Vice President Richard Nixon, and Khrushchev's appearance on *Face the Nation* in 1957. But the Soviet state lacked the infrastructure and will to make its promises of plenty a reality. What's more, state officials and idealogues debated ceaselessly the ethics of private property and consumption and tried to square it with socialist ideology.

However, in the earlier years of Brezhnev's time, consumption levels did increase and access to goods like household appliances and fashion steadily grew. This was the age of the Soviet baby boomers coming of age. Prices were held low, and wages gradually improved, providing a renewed

atmosphere of access and consumer possibilities. One scholar argues that the Brezhnevite shift to consumer satisfaction reflects the leadership's attempt to prove its legitimacy by distancing itself from Khrushchev's de-Stalinization and failed promise to improve living standards.[1] As another scholar put it, "the contradictions within the ideology of socialist consumption that were characteristic under Khrushchev were exacerbated under Brezhnev."[2] The debates about the ethics of consumption and private property gave way to an admittance that workers needed some material satisfaction in order to keep up enthusiasm for socialist construction. First Deputy Premier Aleksei Kosygin maintained that in order for socialism to break out of stagnation, the material needs of the workers had to be satisfied to some degree.[3] The notion of the USSR as a bountiful land ripe for cultivation and development with an abundance of resources, waiting to be made available for all, intensified under Khrushchev and did not disappear with Brezhnev; even in *Vii*, massive panoramic shots of the Ukrainian landscape convey a love for the land, and an appreciation for fertility and possibilities. Over time, though, as growth in consumer production increased, officials realized that the artificially ramped-up production sector would have to keep up.[4]

Personal automobile consumption is a well-studied and illustrative case study. Under Khrushchev, the government acknowledged that average workers desired cars, but the state had little initiative to make automobiles widely accessible. In the decade after Stalin, automobiles continued to be manufactured, but the infrastructure and funding to make them goods for popular consumption, such as gas stations, reliable roads, and replacement parts, simply did not exist at a level comparable to the West.[5] By the time Brezhnev became the head of the Party, emphasis shifted both to satisfying the popular desire for automobiles and increasing public approval for car ownership. Critics warned that personal automobiles led straight to elicit

activities like smuggling and black markets, but this was a "little deal" that the regime willingly acquiesced to: the state would tolerate petty private economic activities, legal and illegal, in exchange for macrolevel managerial discretion in disciplining overt political dissent.[6]

Thus, while popular post-Gorbachev lore has branded the Brezhnev years as the "Era of Stagnation," recent scholars are challenging that narrative by measuring how Russians remembered the 1970s and their overall quality of life. As evidence, they point to the Party's shifting commitment to consumer satisfaction and raising the standard of living, which peaked in the first half of Brezhnev's leadership. New consumer goods like jeans and rock music opened Soviet culture to new horizons and expanded consumers' understanding of what was possible under mature socialism. Edwin Bacon and Mark Sandle consider this period to be a veritable "social revolution" that witnessed an increase in education, urban development, and professionalization.[7] This led them to describe the period as a golden age of the Soviet Union, stating that Brezhnev the General Secretary—including his disastrous foreign policy and at times embarrassing public presentation—should not be confused with life under Brezhnev. In terms of lived experience, life in the USSR after 1964 seemed to be improving, and many scholars attribute that to increasing spending power and expansion of consumer security. The parallels with the post-Napoleonic apogee of the Russian empire that provided a setting for Gogol's story parallels the stature of life in high Brezhnevism.

In this atmosphere of consumer spending, some critics still maintained that if these new freedoms and possibilities came unhinged, uncontrolled, then they threatened to undercut the entire theoretical basis of Soviet anti-capitalism. One was supposed to consume only what was absolutely necessary, "from each according to his ability, to each according to his needs" as Marx wrote in the Gotha Program.[8] What would

happen if these new forms of consumer culture ran rampant, and the state lost control of consumer habits? What if Soviet man became no different to his capitalist counterpart and started buying things simply for pleasure, using and abusing goods without regard for the socialist ethos of what is ideologically sound and necessary for a member of the proletariat state? Indeed, these debates over the ethics of consumption under socialism were as old as the state itself, but the shopping spree that Brezhnev unlocked (no matter how mild when compared to the West) opened the flood gates for renewed debates over how much consumption was too much, and what qualified as "rational consumption."[9] Some Party members maintained a cautious approach that stressed the negative effects of emerging culture, arguing that consumers needed to be supervised in order to avoid ideological degradation.[10] Such a fear seems almost foolish to us today, but to the nomenklatura of the USSR and those who were committed to the communist ideal, such a slip into moral degeneration would doom the Socialist experiment for good. *Vii* fits perfectly in the late 1960s because it is precisely a story about the consequences of Khoma's overindulgence and moral denigration.

The Film

The film's success and innovation come as no surprise considering the minds involved either directly or behind the scenes. Ivan Pyryev (*They Met in Moscow*, 1941 and *Ballad of Siberia*, 1947), originally brought on as director, forfeited responsibility to Ershov and Kropachev, but maintained overall supervision over decision making. Finding fault with Ershov and Kropachev's original storyline, Pyryev eventually recruited seasoned filmmaker Aleksandr Ptushko to help as screen writer and set director. With colorful sets and panoramic landscapes like in *Ilya Muromets* (1959) and *Sampo* (1952), the traces of Ptushko's wild imagination are hard to overlook. However, the

horror aspect separates it from popular folk cinema at the time, which usually focused on gallant prices and their triumphant defeat over external forces, or devils doing mischievous things in villages. Ershov, Kropachev, and Ptushko's dedication to effects and cob-webbed set design are unlike anything in the USSR up to that time, and its use of religious visuals expresses a type of old-time horror that elicits our modern fascination with folk tales of witches and devils. There are even a few scenes where the directors utilize the jump scare technique, for example when Khoma (Leonid Kravlev) first opens the bible, and a crow flies out, or when a gang of cats loudly scatter across the church floor. The reason why we cannot help but experience this film as a horror movie is precisely because of our unfamiliarity with the setting and the unexpectedness of what happens. Not only does it transplant the viewer back to the nineteenth century, but it also puts us in a patriarchal village where the only sources of light are candles. The genius of its presentation is that the creators captured the same naivety that Gogol sought to depict in his original story, but through set design, make up, exaggerated facial expressions, and acting. This makes the plot similar to classical Hollywood in that the story is developed by the actions of the protagonist, but the narrative structure retains its folkish elements and breaks with tradition by killing off the protagonist.

The film adaptation of Khoma is similar to the story in that he's naive and mostly oblivious, but emphasis is heavily laid on his gluttonous habits. In the opening scenes, while the seminarians are reciting their prayers for the rector, Khoma is silent, anticipating nothing but release from the seminary—a sign that he cares little for the routine of spiritual maintenance and all for the pleasure of personal escape. When he gets lost with his friends, Khoma is the one not content to sleep under the stars and insists on finding a house or village. They find the old woman who asks them to leave, but Khoma implies

that making them sleep outside would be nothing short of a sin against Christian souls. He then proceeds to hassle the old women (Nikolai Kutuzov) for food and drink, and when denied he steals a fish from his friend's pack. Khoma does almost everything in his power at the beginning of the film to demonstrate his vanity and overindulgence, harkening back to the original purpose of the story, but also foreshadowing that he's in for a reckoning with powers he can't manipulate.

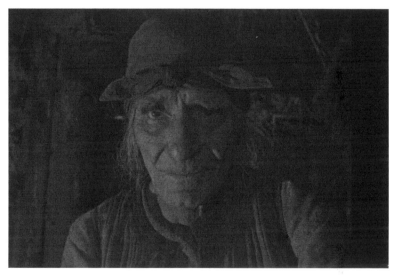

Nikolai Kutuzov playing the old witch

The creators established a horror atmosphere from more than just visual signals and jump scares. Through the first half of the film, while Khoma is in custody by Cossacks, the viewer feels a sense of claustrophobia, like there's no escaping Khoma's fate. For instance, the scene where he drinks with the mustached men who are asking him about how they might become philosophers. They're puzzled by the number of books he must read, and Khoma begins to feel some semblance of comfort around the men taking interest in him. In his comfort he attempts to escape, but as he rises the camera, positioned

directly behind him, wavers left and right to depict his inebriation. It suggests that the Cossacks, rather than being his friends, liquored him up in order to cut off his ability to flee—a kind of living nightmare of inebriated captivity. In a stupor, he hallucinates the same Cossack opening the same three doors in parallel to each other, daring him to leave. The three images might symbolize the three nights he is to spend giving prayers to a corpse. Finally, Khoma cracks, and the camera gives us a close-up shot of his drunkenly distorted face as he implores "Let me go! Let me go!" Of course, nobody listens to him, and he falls asleep.

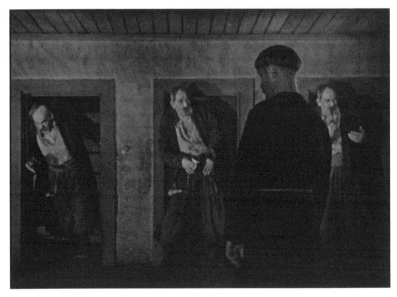

Drunk Khoma's Three Options

It's in the three church scenes that the gluttony of Khoma really becomes most evident. He gets drunk before each night, presumably to ease his fear, but commits the sin of walking on consecrated ground intoxicated. He also takes a sniff of snuff each night he comes to the pulpit, evincing his disregard for sacred ground and demonstrating his real

inability to refrain from sumptuousness even in the face of certain death. The script writer made sure to emphasize this point by having Khoma cling to his tobacco like it's his last life-line—the camera zooms in to a close up as he says "good [*dobry*] tobacco. Glorious tobacco. Good [khoroshii] tobacco," revering the commodity as a God. To drive the point home, the camera frequently squares on the contemptuous face of Jesus Christ and Mary with Child who look at him as a condemned soul, like the eye of the state watching over Soviet consumers.

The church scenes are also important for the visual and technical effects the creators used to show the witch's power, which were innovative for the 1960s in any country. For instance, Natalia Varley, who played Pannochka, the dead witch, recounts how the set designers created a moving contraption to make it appear as though the coffin floated in the air. In one scene we see it mechanically circle Khoma with the witch standing on top desperately trying to find the young philosopher. Varley, despite being a gymnast, fell off the contraption at least once during filming, evincing the lengths that set designers would go to achieve the desired effect.[11] The music in the church scenes is equally as innovative in the way it builds suspense by intensifying over time and pairing rhythmically with the actions of the characters. The music increases in intensity and volume until the point where it and Khoma's fear almost clip the audio track, and rather than fade out, it abruptly stops, usually with the coo of a rooster to signify the end of night. As the witch descends back to her coffin, the lid slams shut and the camera, using the substitution splice technique, cuts to a dark room with all candles out and Khoma exhausted. Each night involves the same activities, but Khoma's mental and physical states progressively deteriorate, embodied by both his graying hair and dead stare, made extremely visual through Kuravlev's natural blue eyes.

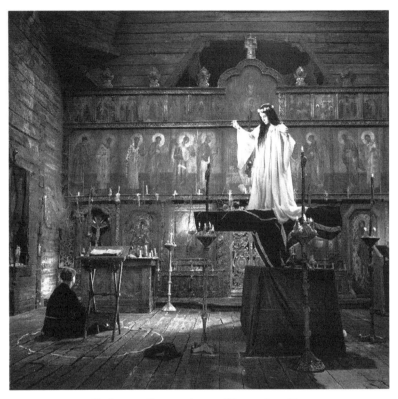

Varley on the moving coffin contraption

At first sight it appears that one of the strangest aspects of this film is its use of religious imagery to convey a moral and ethical message within an officially atheist state film industry. However, Ptushko was a master of appropriating folktales for a contemporary audience, as long as the films were understood to be fantasy and folklore, and therefore historically rooted in the USSR's archaic past. He had a lot of creative freedom, but some say he held back the creativity of the young directors. One commentator claims that Ershov and Kropachev originally intended for the film to be more erotic and horrific, understanding the metaphor of Khoma and the witch to be a sexual one. He claims that Vii was envisioned to be a monsterized rendition of Pannochka's father, who was supposed to break through the

floor, symbolizing how "the heart broken father and the terrible monster are one in the same [showing] the relative concepts of good and evil."[12] Supposedly, the director cut some scenes out because they were too horrific and could not be justified under the guise of folklore, but all deleted footage has been destroyed, so we are only left to speculate.

Hence, Gogol's prologue in the story served the same purpose for Ershov's film— it reinforced the idea that *Vii* is a fictious story with superstition and symbolism that harkens back to when people were simple minded, and it can be used to make a point. Across time and space, the message remained the same, albeit the contemptuous eye of Gogol's God was replaced by the State. There is a special place in hell— either religious or socialist hell— for those who incur the wrath of authority through their indulgences.

In reality what might be the strangest aspect of the film is its sheer existence. While the possibilities of Soviet cultural production were expanding under Brezhnev, the Party nomenklatura, as well as society at large, feared the repercussions of transgressing Marx's most famous maxim; they feared that consumer availability would outpace needs, and that gluttony would replace conscious choices. Paradoxically, the film that conveyed the fear of that process also participated in its longevity by resurrecting horror for Soviet movie goers.

Chapter 2

Reclaiming National Pasts: King Stakh's Wild Hunt [*Dikaia okhota korolia Stakha*] (1979)

Uladzimir Korotkevich's novel *King Stakh's Wild Hunt* is a gothic rendition of Arthur Conan Doyle's "The Hound of the Baskervilles," that incorporates Belarusian folklore and national myth with elements of Western gothic literature. The story is fundamentally about Belarusian identity in a world that is rapidly changing—where the forms of "modernity" imported to the Russian Empire are eliminating national particularities. On the one hand, the hereditary Belarusian aristocracy in place before the Russian Empire's absorption of the land is disappearing, and on the other hand science is debunking archaic superstitions that still exist in the countryside. The novel addresses "Little Russia's" forced transformation under "Big Russian" suzerainty, but the fact that it was written in the 1950s and 60s speaks to the subliminal continuation of that process under Soviet rule. More specifically, *King Stakh's Wild Hunt* is an allegory of Belarus' experience in the Stalinist terror and World War Two, where Moscow's drive for ideological conformity caused the suffering of thousands of notable Belarusian intellectuals and politicians.

Written in 1958 but published in 1964, the book came out in the later years of the Khrushchev era, as anti-religious campaigns heightened, entire cities were built for the purpose of scientific study (Akademgorodok), and drought and bad harvests ravaged the Soviet countryside. After World War Two, Belarus' position within the "borderlands" between the Soviet Union and the former Nazi regime meant that the destruction caused at the hands of foreigners instigated a deep self-reflection on Belarus'

complicated history and future. Andrei Beloretskii (literally a play on the word Belarus), the main character of the book, seems to talk for the author when he reflects: "I sought my people and began to understand, as did many others at the time, that my people was here, at my side, but that for 2 centuries the ability to comprehend this fact had been beaten out of the minds of our intelligentsia. That is why I chose an unusual profession for myself—I was going to study and embrace this people." What Korotkevich does is to subject the Belarusian national folk tale of King Stakh's Hunt to an intriguing gothic atmosphere and plot, where the message of the story is both the trouble with national and personal alienation, particularly after Belarus' experience during Stalin's terror and World War Two, and the confrontation with a reality that is sometimes hard to accept.

The Context

Production of the film started in the middle of Brezhnev's time in office, long after Khrushchev's de-Stalinization campaign, which gave intellectuals and would-be dissidents a hopeful sense of future possibilities. By the mid-1970s, Party discipline once again tightened, and the film's topic of terror-through-isolation conveys a sense of uneasiness over the repressive tendencies of the later Brezhnev regime. As Brezhnev started to show obvious signs of aging and members of the Central Committee had to step into a role of indirect rule, intellectuals feared an end to the "little deal" and a return to the surveillance state and repression of high Stalinism.

The mid-1970s is known popularly as the moment when dissident voices began to be heard inside and outside the Soviet Union. *Samizdat* and other forms of illegal literature proliferated, and people came to appreciate the new (albeit limited) freedoms associated with Brezhnev's "little deal," mentioned in the previous chapter. At the heart of the new cultural atmosphere was a long-standing tension between the

Stalinist state apparatus and national intelligentsias, who had suffered at the hands of state agents and cultural censors under Stalin. One of the most famous dissident trials, that of Siniavskii and Daniel in the 1960s, pitted the intelligentsia against the regime for the first time in a while and led to some of the first public demonstrations in support of the intellectuals. Opponents of the regime's actions interpreted the trail as a warning to other intellectuals who brought the new freedoms too far by piquing public interest in questions of national autonomy. The state reacted with force with a new round of arrests, and it clamped down on the intellectual freedoms granted after 1953. The intelligentsia, including the producers of culture, feared a return to the paranoid state of capricious arrest and censorship of the 1930s. Least this argument be confused with the one made in the previous chapter on *Vii*, it's worth remembering that quality of life can improve in terms of consumer goods and purchasing power in conjunction with fear of cultural regression and censorship. While the "little deal" was an opportunity that many seized, veterans of the past, particularly those of non-Russian ethnicity, knew that such things could be revoked at any moment by the Party.

A lot of people within the Soviet Union looked to their national identities for intellectual shelter. Hence, the film adaptation of Korotkevich's story at a time of renewed fear of repression seems hardly a coincidence, and its foregrounding of Belarusian folklore and identity in the context of a story about personal terror demands to be understood as a symbolic acknowledgment of Belarusian struggles under Stalin. Coming out of Khrushchev's de-Stalinization, the story is fundamentally a critique of the purges and anti-Belarusian nationalism campaign that targeted the intelligentsia of Belarus blamed for "bourgeois nationalism." That explains why the book is loaded to references of a distinct Belarusian culture—the story itself is supposedly derived from the tale of an ancient Belarusian

King Stakh. Beloretskii's interest in local folklore is almost a middle finger to Party members who purged pedagogical institutes and universities claiming that they did not "study one another and the individual non-Party students."[1] While that refers to Party members unwillingness to spy on each other, Korotkevich's point in the story is that Belarusians can and do study themselves, that they are cognizant of a past independent of Russian suzerainty. The novelist was painfully aware of the Party's effort to expunge Belarusian nationalism from the state apparatus, so he sought to create a character that was distinctly Belarusian, studying the aristocratic myths and rural communities of a distinctly Belarusian moment in history. The main character himself, Andrei Beloretskii, is a metaphor for the cultural intelligentsia's responsibility toward the community it serves and writes about.

From 1921, Belarus experienced a number of Party purges that varied in degree. The first purge, in 1921, removed some 1495 members of the Party in an effort to establish ideological homogeneity, and most of these people were allowed to exist freely outside of the Party. The next purge, in 1929-1931, specifically targeted academics, National Democrats, and followers of Nikolai Bukharin and Aleksei Rykov, leaders of the so-called "Right Opposition." One scholar points out that members within the People's Commissariat of Education were a primary target because the Party saw it as a breeding ground for theorists of bourgeois national sentiment. The pattern renewed in the purges of 1933-1934, as the Party blamed teachers and faculties at academies and institutes, particularly in Minsk, Beloretskii's place of origin, for "counter-revolutionary" tendencies. Imagine living in a country where your creative intelligentsia are systemically eliminated repeatedly for over a decade, and then Nazis invade. World War Two did not offer much reprise: the 3-year German occupation of Belarus saw hundreds of villages and towns destroyed, entire institutes

pilfered of national relics, and industry reduced to about 20 percent of its pre-war capacity.[2] By 1945, Belarusian culture had endured terror and repeated trauma for nearly a quarter decade.

Belarus was not alone in its experience—Uzbekistan, the Baltic States, and particularly Ukraine experienced similar national repressions and traumas throughout the Stalinist period and World War, thanks in part to their geography between Germany and Russia.[3] But even though national movements practically disappeared between 1928-1940, the repeated invasions and bombings of World War Two renewed Stalin's energy to totally Russify the republics and replace national Party officials with ethnic Russians. Stalin's policy after the war centered the primacy of the CPSU in Moscow, and his speech to Red Army commanders on May 24, 1945, glorified Russians above all other nationalities in the Union.[4] By 1953 the Belarusian Communist Party and government contained almost no ethnic Belarusians, and the party continued its attack on the intelligentsia up to the last years of Stalin's life. It's no wonder that by 1986, with the initiation of *glasnost* and *perestroika*, public calls for national recognition and particularity—cloaked in environmentalism, preservationism, and anti-Russianism among other things— began almost immediately.

Because there is no historic evidence of King Stakh the person, one can only speculate that the "Wild Hunt" of the king and his henchmen refers to the hunt of the Belarusian intelligentsia during the terror. As one scholar argues, Beloretskii embodies the ideal Belarusian leader—national in form and altruistic in content—who combats those who unjustly betray his people.[5] In a weird way he is a national hero at a time when Belarusian national heroes seemed just as disassociated from the people and just as decrepit as the castles in Belarus. The fact that *Belarus'fil'm* productions sought to recreate it in 1979 evinces the fact that the story's particularism resonated with the studio, and according to director Valerii Rubinchik, "probably all

Belarusian directors dreamed of making a film based on the story 'King Stakh's Wild Hunt.'"[6] At a time of cultural laxity, Belarusians could enjoy minor forms of cultural expression, as the creative intelligentsia benefited from the "little deal" of the late Brezhnev years and sought to render a film about a terror in Belarus. Yet, despite the obvious national message of the original story, the film, along with contemporary reviews, downplayed elements of the story that addressed or symbolized Belarus's past.[7] What we end up with is a film about Belarus, by Belarusians that misses the prescient Belarusian message.

The Narrative

The story begins with the hero, Andrei Beloretskii, a young anthropologist traveling from Minsk to a more remote region to study the folklore of his native Belarusian people. Along the way, he gets lost in a rainstorm and stumbles upon a half-decrepit mansion belonging to the ancient aristocratic Ianovskii family. The mansion is occupied solely by the last of the Ianovskii line, Nadezhda Ianovskaia.

One night, Yankovskaia tells Beloretskii about paranormal occurrences in and around the mansion. For one, there is a "lady in blue" that roams the hallways in the dark, who she suspects is the ghost of a distant relative. Then there is the sound of tiny footsteps running about the mansion, a phenomenon that Beloretskii experiences early in the story. Finally, and most importantly, there is a gang of phantom horseman roaming the grounds and fields of the Ianovskii estate at night, seeking to fulfill an ancient promise to kill the last of the Ianovskii line. They seek to do so in order to avenge the murder of the ancient King Stakh, who promised to improve the lot of the surrounding peasants through land reform, thereby forfeiting some of the aristocracy's power.

As a man of science, Beloretskii does not believe that any of the supernatural occurrences are truly other-worldly.

After witnessing how these hauntings torment Ianovskaia, Beloretskii decides to stay at the mansion and help her find the culprit(s). We meet first her protector, the elder Rygor Dubotovik, and his follower Ales' Vorona, who once tried to court Ianovskaia; house servants; and people who live around the land of Mars Furs. Importantly, Beloretskii is the only member of the "intelligentsia" in the novel, which explains his skepticism and distain for the archaic social structure in the village.

There are many narrative threads throughout this book. The first is the larger description of petty feuds and tense social relations between the Belarusian people that parodies Old Regime society. Beloretskii is a member of the educated intelligentsia, Yankovskaia and Dubotovik are aristocrats, and the peasantry face the brunt of their feuds. The phantom King Stakh, the would-be liberator, embodies the antagonism between the old aristocracy of the Yankovski line, and is willing to grant some social concessions. Rather than an ancient bloodlust, Beloretskii suspects that the hunt must be conducted by someone with an interest in inheriting the Ianovskii property, either another aristocratic line, or members of the disgruntled peasant population (everyone, at every level of the social structure, is greedy and unhappy and therefore suspect).

The other narrative is the classic sleuth story featuring an intuitive but lonely individual recruiting the help of local outcasts to solve a mystery. Finally, as he witnesses the gambit of Ianovskaia's erratic emotions and behaviors, Beloretskii becomes infatuated with her to the point where his purely scientific endeavor becomes a labor of love. Over time he assigns himself the role of her protector. All these narratives are strung together through the common theme of alienation, an idea first pointed out by Imran Khan in their review of the English translation of the book. The social

estates are alienated from each other, Beloretskii is literally an alien from the community of folk Belarusians because of his social status, and the love he feels for Ianovskaia is the only thing saving him, and the only force pulling her out of years of personal trauma and alienation at the hands of the phantoms. The story is about the mutual dependency of Belarus' people.

The Film

Korotkevich wrote the first version of this script, but it was scraped by Rubinchik because it was too "literary." The director envisioned more of a detective melodrama than the author initially intended.[8] Nevertheless, the 1979 film retains the skeleton of the novel but adds some significant changes to the message and plot. For one, the story takes place in 1899, which may seem unimportant, but becomes symbolic when the viewer hears the final line: "Today is the first day of the twentieth century" and the camera shifts to peasant children along Beloretskii's (Boris Plotnikov) way to St Petersburg. Along with the triumph of science over superstition, a theme retained in the film, Rubinchik and the writers wanted to emphasize the coming of a transformative century that would (ostensibly) liberate the Belarusian peasants from squalor and subjugation from out-of-touch nobles. More contemporaneously, the reference to a new century alludes to a sense of hopefulness—an optimistic outlook that leaves the past in the past and looks forward after a moment of abject terror. This is a message that pays lip service to life in post-Stalinist USSR, which for countries like Belarus offered the promise of renewal.

Still, it's the smaller details in the film that reveal more about what makes it a relic of its time and an important experiment into the horror genre. For example, time is compressed (Beloretskii solves the mystery of the blue lady

and the little footsteps much quicker), and his companions Andrei Svetilovich and Ignatius Berman-Gatsevich die much sooner in the film. Its feels as though the director did not fully understand their importance to the novel but did not want to omit them outright from the film, so we get a forced introduction. When they die, it's not clear exactly how the viewer is supposed to feel. Basically, the characters are not developed well enough to feel the same kind of remorse that the book invokes.

More profoundly, and more historically relevant, is the fact that the film clearly recognizes the book's theme of alienation, and yet misses its full implication. The opening scene of the film is the camera looking through a keyhole, conveying a sense of blocked-off peripheral vision and narrow self-alienation. Almost every scene successfully conveys the discomfort of the characters; at the ball, the aristocrats' faces are blank, and Ianovskaia's (Elena Dimitrova) facial expressions convey an insular torment that captures the feeling of the heiress in the book perfectly. Even when Beloretskii discovers the "invalid" brother of Ignatius, Bazil Gatsevich (Vladimir Fedorov), instead of getting angry and talking down to him, as he does in the book, he invites him outside to play in the snow. The cure for all these characters' afflictions is an interaction with Beloretskii—an outsider and intelligent—who can liberate them from the confines of their minds and the creaky old castle, thereby alleviating their terror. It's a commentary on the liberating qualities of socialization and education—the intelligentsia's power to literally free the household from the terror of the ghost-hunters. However, the unfortunate part of this depiction is that the Beloretskii's particularism as a "Belarusian" is abstracted out, so that he no longer represents Belarus, and is a harbinger of a new century, perhaps a Bolshevik-to-be.

Beloretskii in the awkward Ianovskaia ball

Horror in the film is established through technical details that highlight the somber atmosphere of Mars Furs and the torment of Ianovskaia. Generally, the audio on the film can be best described as hollow, as there are many moments of straight dialog with minimal music in the background. Instead, we hear the occasional beat of a drum and gust of wind, but the characters are often involved in excessive dialog through close-up shots. There are three dominant musical leitmotifs provided by Belarusian composer Evgeniii Glebov. As an ode to Belarusian folk, gusli music plays with a mellow string orchestra, including a bayan, every time the camera captures something that is supposed to elicit our sympathy, like characters exchanging loving glances, or going about their day as if they are not haunted by terror. In contrast to that, suspenseful music punctuated by church bells and horse galloping growing in intensity plays as the hunting phantoms are depicted. In one of the more notable scenes from the film, Beloretskii is shown running from the charging herd

in slow motion, crosscut with the horses charging at normal speed. In the climactic scene, in which Beloretskii and a gang of peasants confront the terroristic phantoms, a somber voice synth with vibrato and slight thudding at 120 BPM in the background plays to capture an intense heart rate before the final reveal. That music continues throughout the end, as they chase the antagonist to a dilapidated home and burn it. The scant musical score at times of intense character development and activity accentuates the feeling of alienation and foreboding, giving the entire atmosphere of the film and earie sense of a land forgotten.

Beloretskii running from phantom horsemen in the foggy land of Mars Furs

These elements stressed the underlying themes of alienation and the elevated status of the intelligentsia as heroes. However, as mentioned above, alienation in the novel works on various scales—from the personal to the national—and it is the national element that Rubinchik's film sadly omits almost entirely.

Indeed, if a major topic of the novel is the importance of myth and identity in late nineteenth-century Belarus, the film dispenses with explicit reference to that entirely in favor of a blanket critique of the Old Regime. Besides the publishing studio, set, composer, and director, there are few direct references to Belarus, and even most actors are Russian. The creators relied on the obvious knowledge that the story is Belarusian in content, if not in form, and either out of fear of producing such an obvious national tale, or in an effort to appeal to a broader audience, they chose not to mention Belarus. This creative choice, rather than providing a counterpoint to the claim that it's appearance at the time represents the re-emergence of national sentiment, proves the point: Belarusian creators managed to push the story through as long as they tamed the censorable aspects. Fear of repression went a long way in taming expressions of national trauma and ethnic terror, but it could not stop people from referring passively to those things in their art.

Hence, Rubinchik's film *King Stakh's Wild Hunt* came at a time when the Soviet people, particularly non-Russians, started to feel a pervasive sense of alienation, from the upper echelons of the CPSU—those who formally went along with the Stalinist system—to the lowest rungs of individuals who feared that their voices would no longer be heard. On the national level, Belarusians, along with other nationalities within the USSR, began to show signs of resistance to the centralizing tendencies of Moscow. As we'll see, these national tensions erupted by the 1980s into full-blown independence movements. Even the creators of the film who loosely identified with the intelligentsia feared alienation from the freedom to realize their full creativity. That may partially explain why the sad, wacky, and abstract scenes of the book are omitted from the film, and why the author's original screen play was scrapped altogether. So, while the film misses its mark on the nationalities question, it still depicts a sense of temporal significance. The historical

moment is a key idea and context in the film, as evidenced by the final lines that allude to the coming of a new century, and the sense of a crossroads, of the importance of "now" that captures the fears, hopes, and general attitude of Soviet citizens toward the end of the 1970s. Fear of the past and of an unknown future literally haunt the film *King Stakh's Wild Hunt*.

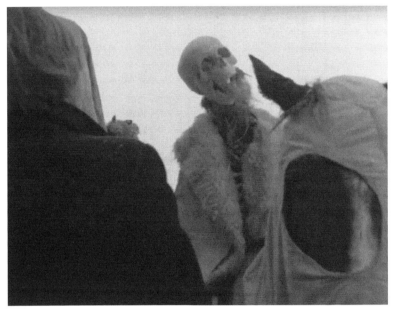

Beloretskii's reveal of the phantom to be nothing but a skeleton

Chapter 3

Religion and Spirituality in Mister Designer [*Gospodin Oformitel*] (1987)

"Beware of things! They enslave us quickly and thoroughly," can be read as a Marxist warning not to fetishize the commodity as much as a religious caution to avoid worshiping false idols. Hence, the line echoes with several issues that come up in late Soviet society. In the case of commodity fetishism, we've already used *Vii* to explore the USSR's reluctant acceptance of socialist consumer culture. Put in its proper context, though, the line is a reflection on preserving the spiritual sanctity of human autonomy and thought, to avoid losing our humble sense of self and solidarity in the interest of fulfilling our promethean urge to act as Gods over the earth.

For many people in the Soviet Union who knew this and wanted to believe it, the ideological straitjacket of Soviet Marxism provided little by way of spiritual understanding and release. If Marxism explained the socioeconomic realities of the world, what accounted for spiritual perceptions? As is well known, Marx wrote "Religion is the sigh of the oppressed creature, the heart of a heartless world, and the soul of soulless conditions. It is the opium of the people."[1] Yet, as we'll see in this chapter, Soviet people never stopped believing, even when their state actively sought to silence religious institutions. With the loosening of restrictions and a relaxation of the regime's control, the Central Committee, led by Gorbachev, allowed for the re-emergence of public faith, especially Russian Orthodoxy, into popular Soviet parlance. The 1987 film *Gospodin Oformitel* is the cinematic depiction of that line by Aleksandr Grin, and through its frequent use of religious imagery, it engages in the re-introduction of spirituality as an important element of the

45

human condition.

The Narrative

Gospodin Oformitel is a very loose rendition of Aleksandr Grin's short story *The Gray Automobile*. The story follows the attempt of Ebenezer Sydney to woo Corrida El-Basso, a woman he professes to love. He tells her early on that he's been working on an "invention" in Kahlo Canyon, and that he intends to show her when the time is right.

However, Sydney suspects that he is being haunted by an automobile, particularly a model S.S. 77-7, that appears at opportune moments throughout the story, suggesting that the automobile has a consciousness and is purposefully seeking out the protagonist. Grin is a master of describing objects in such a way that they take on a life of their own outside of the characters.

In one of the most notable scenes in the story, Sydney strolls into Lerkh Casino and decides to press his luck against gambling tycoon Emmanuel Grignio, who has been running the table all night. Grin describes the cards as though they determine the luck of the player, and the wild joker card, with its power to determine the outcome of the game, becomes an object of obsession for Sydney. The crowd watches on as his winning hand upsets the wealthy player by exacting half a million dollars from him, but he learns later that Grignio intends to pay a portion of his debt with his S.S. 77-7 automobile. Sydney is frightened at the prospect of the automobile entering his life, but in a moment of luck Grignio has a brain hemorrhage and dies, leaving Sydney to believe that nobody will know to give him the car.

When he returns to his room, he hears neighbors having a convenient conversation about futurism, an art form of the early twentieth century (indicating, perhaps, the time frame of the story). One character, Nikolai, says that he feels like futurists

show him garbage art and try to paint it as a masterpiece. He says futurist artists are like "overgrown kids that ring your doorbell and run away because they have nothing to say." Sydney decides to chime in with his positive defense of futurism, retorting that the tradition must be considered in association with something else. By this he means that an automobile, for example, must have a separate point of view from human perception. The central idea, according to Sydney, is that human perception cannot be the only form of perception on earth, and that anything moving, including an automobile, has a conscience. Thus, Sydney speculates how a car must perceive a human:

> Faced with phenomena, such as a human face, we sense a human creature, see the connection and the light of life—something a car cannot see. Its impressions, essentially, can only be geometric. Therefore, the human-like combination of triangles with squares or semicircles, decorated by a single eye—something a simpleton would be confused or even puzzled by—must be a Car's impression of a Human.

Hence, objects perceive the world not through the human retina and cognition, but through their own dimensional lenses. Futurists sought to represent what the world might look like to something like an automobile.

This discussion reflects a broader understanding of futurist art from the early twentieth century, particularly in Russia, that emphasized the beauty of machines as a new aesthetic. Artists like Daniel Burliuk, Kazimir Malevich, and Vladimir Maiakovskii focused their craft on depicting a completely modern world represented by angular designs and automation. Futurists discarded representations of the past except for the occasional ode to folk life and religion, which represented a distinct Russian "spiritual" heritage. For example, the portrait

below by David Burliuk is of Vasilii Kamenskii, a futurist poet and playwright, and one of Russia's first aviators. To make his representation of the writer, Burliuk borrowed heavily from the tradition of Orthodox Christian icons, where the bust is front and center, and the glowing halo emphasizes the sanctity of the figure. The two separate shaped eyes are reminiscent of Christ Pantocrator (Sinai), a Byzantine icon that emphasized the dual nature of Christ as fully God and fully Human. In this painting, Burliuk emphasizes the duality of Kamenskii as someone enthralled by modern machines (aviation in this case) and drawn by the folk tradition of Russia in his literary endeavors. In this case, the icon as an object depicts someone that we know had an independent conscious. All of this is to say that Russian futurism, for its emphasis on modernity and machines, derived inspiration from Russian religious and folk traditions, particularly iconography.

"Portrait of Vasily Kamenskii," 1916 by David Burliuk.
The Russian Museum.

After this conversation Sydney calls Corrida in a desperate attempt to hear her voice. He claims that he finished his invention and offers to show her in an exclusive preview. After she agrees to go with him, Sydney receives a phone call from a representative of Grignio, reminding him of the car that he won in the card game. Frightened, Sydney refuses to hear the representative and throws down the receiver. Just when he thought the car was out of his life and the debt paid, he is suddenly confronted with Grignio's people.

Corrida arrives and he teases her with some references to his invention. As they travel out of the city toward Kahlo Canyon, they engage in some trivial conversation to pass the time and ease Sydney's own discomfort. He tells Corrida about his refusal of the automobile, which she attributes to his "mania" that she's "heard so much about." The two characters get into a broader conversation about the increasing societal need for speed, again referring to the futurist aesthetic of modern machines.

Throughout the conversation, Sydney keeps planting cryptic questions about death like "If you died...and then were reborn with the memory of your prior life—would you continue living as you do now?" Corrida at this point is a little freaked out, but they continue moving toward the canyon.

Finally, Sydney asks, "Why, and for what purpose, did you leave...the store?" We learn that he believes Corrida to be a mannequin come to life, and at this point the reader is left to decide whether Sydney is telling the truth: is Corrida an "object" from a store or is his mania promoting this delusion? We are left only with the perspective of Sydney, who notes that Corrida's complexion and tone change after asking the question. He leads her toward the edge of a canyon, overcome with "insane delight," and then he tries to throw her from the edge so that she can be reborn as an actual human.

Corrida slips away and pulls out a revolver, firing a shot that grazes Sydney's left temple. They have a standoff that culminates

in the protagonist's admission that he intended for them both to jump off the cliff to be resurrected, because "true, genuine life will revive in you only after annihilation, after death, after rejection of all things!" Corrida, ignoring the ravings of someone who is most certainly perceived to be a madman at this point, offers to go and get help before he bleeds out.

Sydney gets up and moves back toward the road, fearing that he is being hunted by people out for revenge on Corrida's behalf. As he grows weaker, the sounds of an approaching automobile, presumably the gray S.S. 77-7, get louder.

At the end of the story, Sydney wakes up in a mental institution, and we are left to wonder whether the events described happened, or if they were some kind of delusion.

The Context

Futurism offered a way for people to fuse their belief in technology and the modern world with a spiritual understanding of conscience and connectedness. At the turn of the twentieth century, humanity's ability to transform nature through machines, infrastructure, and aviation (a new limitless faith in science) reinforced revolutionary doubts over the value and purpose of religion. Science reigned supreme, and it seemed, at least to socialists, that Marx told the truth about religion in that it held people back from realizing the possibilities of human ingenuity and liberatory politics.

As the first Socialist state to bring Marx's theory to practice, the USSR sought to diminish or eliminate its people's adherence to religion. In the early years of the Soviet Union this manifested as an official attack against the established Church. Parishioners, welcoming the revolution of 1917, demanded reform and the ability to admit parish representatives to diocesan assemblies. Assemblies became the new place of decision making within the Church, and they quickly moved to cast off the clerical denomination and retain

control over parish property while reducing the material support of unpopular clergy. When the Bolsheviks came to power, they simply reinforced this revolutionary situation by confirming the power of the parish over the Church and decreed the Separation of Church and State, nationalizing all Church assets and placing all power in the parish. However, the transformation of the Church, much to the chagrin of the Bolsheviks, had the effect of strengthening local religiosity and de-centering religious administration.

The new regime did almost everything in its power to dismantle the institutional Church, short of executing the clergy (although a lot of that did happen as well). During the Civil War, Bolsheviks suspected Orthodox clergy of being counter-revolutionary and moved to further disempower them by increasing their tax rates, barring them from teaching, and excluding their children from Soviet schools. Gregory Freeze calls what happened next a "social revolution in the parish clergy" in that the Orthodox Church became but a shadow of its pre-revolutionary self. This period witnessed the elimination of pre-revolutionary priests, deacons, and psalmists, the seminary system, and the subjugation of priests to the absolute power of the parish. Essentially, this empowered the parishioners to such an extent that when the Bolsheviks sought further exactions from the Church, such as its precious metals, they would have to battle the laity, and not the institution or its heirarchy.[2]

Anti-religious rhetoric continued to pervade Soviet discourse, and in 1929 the government decreed on "religious associations." This signaled the beginning of a "hard line" stance toward all religion—whether institutional or not—that accompanied collectivization of the peasantry. The membership of the "League of Militant Atheists" ballooned to the millions in the effort to publicly combat religion, empowering socialists to do all they could to disrupt religious practice. Parishioners

fought back, and throughout Stalin's General Secretaryship peasant believers put up the most resistance to church reforms and suppression from above. The regime closed more than three-quarters of established churches between 1929 and 1938, effectively ending sites of institutionalized worship and relegating believers to the underground, or at least confining it to the private sphere of the home.

World War Two offered some reprieve, as Stalin recognized the Orthodox Church as a Russian national asset that could be used to strengthen morale and boost confidence in the war effort. However, by 1947, the regime was back on track in promoting anti-religious ideology.[3] The anti-religious campaign continued under Khrushchev, in some cases worse than under Stalin. From 1959 onward, the regime closed more than a third of all registered places of worship, further decreasing the number of venues to publicly practice one's faith.[4] What scholars emphasize in this period is that despite the attempts to snuff out religion altogether, the Soviet Union could not silence popular religiosity. Rather than secularization, there was a laicization of the church, where people, longing to worship as befit their spiritual needs, continued to do so without the institutional Church.

Gorbachev's reforms brought the Orthodox Church back into popular discussions of Russian nationhood and spiritualism. One of the major figures at this time was the public intellectual and medievalist Dmitri Likhachev, who advocated for a regeneration of Russian society through fostering measures to protect and promote Russian culture. In his medieval studies mind, the Russian Orthodox Church was intimately tied to a sense of Russian cultural heritage that needed to be embraced rather than shunned. Gorbachev, looking to ramp up popular support at home and abroad for *perestroika*, welcomed cultural revivalism to a limited extent, but he was cautious not to grant too much room to

particularistic entities that might strengthen nationalist causes.[5] Gorbachev took a cautious but nevertheless liberal stance toward the Church, resuscitating it from its institutional grave as a means of demonstrating to the world that the USSR could grant open religious assembly while still enforcing the Party line. Hence, while religiosity never disappeared in the USSR, *perestroika*, along with the approaching millennium celebrations of St Vladimir's conversion to Christianity in 988, brought religion and its questions to the forefront of Soviet public discourse.

The Film

Gospodin Oformitel emphasizes the tragic outcome of man trying to act as God the creator. The religious connotation of the film is not just something that is made obvious by shots of icons and saints but is reinforced by the spiritual questions posed to the viewers. Indeed, one critic recognized the film as an example of the "return to decadence" or even a "rebirth of decline" that evokes the transformative era of pre-World War One Russia and poses the same quandary that futurists sought to address: how does humanity balance its promethean impulses while retaining its moral and spiritual transcendence of the material world?[6]

The story follows the career of Platon Andreevich (Viktor Avilov), an artist who tries to use his sculpting skills to prolong the life of a woman. His artistic drive is to create something perfect that overcomes humanity's creative limits, framing the goal as a battle with God. He receives a commission from a shop owner to create a mannequin, and in search of a prototype he finds Anna (Anna Demyanenko), a pitiful young woman dying of consumption. He puts all of his skill, even blood, into creating the best mannequin, and discovers an intimate connection with his project.

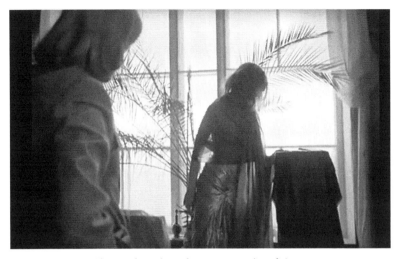

Platon dressing the mannequin of Anna

Years pass and Platon falls into oblivion, abusing morphine (another ode to the early twentieth century) and his career seems all but over. Suddenly, he is invited to decorate the house of a wealthy businessman, Grillo (Mikhail Kozakov). He meets Grillo's wife, Mariia, who is the spitting image of Anna, the mannequin prototype. Platon is convinced that Mariia is the reincarnation of Anna, born from his creation, but she refuses to acknowledge any recollection of the past. Platon's obsession with Mariia-as-object leads him to desperation, and when he proposes to the woman, she refuses because he is too poor. In both cases, the two protagonists demonstrate their enslavement to material objects — one to the ideal mannequin, and the other to wealth. There is thus a tension within Anna between reverence for the one who created, and the riches of the profane world.

The film recreates the card scene from Grin's story almost exactly. Platon upsets Grillo at a game of poker, winning a massive fortune that leads him to propose to Mariia once again, under the expectation that wealth will change her mind. She refuses, not because he's poor this time, but because he keeps referring to her as "Anna." Seeking to prove her wrong, Platon

searches and finds the tomb of Anna, but he's still not convinced. He returns to Grillo's house only to find him dead, and Mariia suddenly willing to marry him. He suspects she is responsible for his patron's death and attacks her with a burning log. The film shows half of her face melting from the burn, but before Platon can act further he's shot in the back by Mariia's friend. He escapes briefly but is run over by a car.

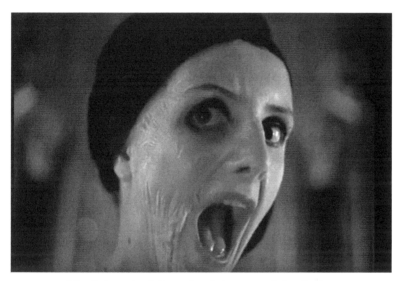

Mariia's melted face after being struck by the log

Gospodin Oformitel was the diploma work of Oleg Teptsov, a graduate of the Higher School of Scriptwriters and Directors. As a former musician with no formal cinematic experience, the film was a rare debut contribution to *perestroika* cinema. One critic recognized that "in an effort to convey the mystical, erotic and apocalyptic atmosphere of decadence, the director followed the path of stringing a whole garland of cultural realities—literary, pictorial, cinematic—within an archetypal plot core."[7] The film shows the parallels between early twentieth-century art and ideas—the sense of impending change—with similar feelings in the mid-1980s USSR.

Religion plays a key role in emphasizing the spiritual insecurity of the time and the tension between man and God that Platon acts out. There are two scenes worth juxtaposing. In the first one, filmed in black and white, Platon walks into a courtyard with a white suit in search of a perfect model to make his mannequin. He stops to talk to a man raking leaves and offers to pay for a recommendation. A woman approaches and she takes him to see the sickly Anna. While we watch Anna cough and shake in bed, the camera cuts to the old woman (presumably her mother) crossing herself as Platon looks on in horror. He glances up and sees an icon in the corner of Mary and Jesus, and the camera fades to a shot of Anna sleeping in bed. From that point on, Platon is seen in white only when he makes decisions, and it is clear that he has decided to use Anna as a muse. His pity for the ailing woman and decision to use her reflects his God-like caprice to decide who is worthy of replication.

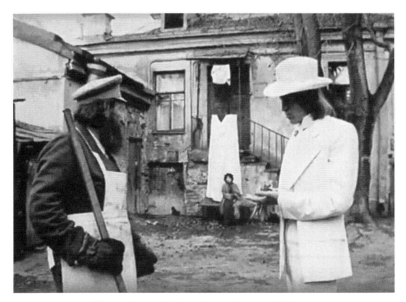

Platon in a white suit paying an old man

The next time he goes to the courtyard is almost by accident: he encounters a nun, who he chases back to the residence of Anna. This time, the picture is in full color, and Platon is wearing a black suit, much like the nun. The chase represents a spiritual pursuit, in which Platon is trying to keep up with the powers of God. Anna's mother is excited to see him, exclaiming that she did not think he'd return. In this scene Platon is humbled by his attempt to play God: the old woman reveres him to the point of dependence, but he is no longer comfortable playing the role.

After Platon creates the mannequin, the camera makes frequent montage cuts to images of children, birth, and God the creator, suggesting that the figure, as a creation of the artist, has taken a life of its own. While Grin's story leaves the status of Corrida up for debate, the film leaves no doubt that Mariia (Anna) is an inexplicable phantom—a dummy come to life.

One of the most unique aspects of this film is the well-executed use of musical motifs. There is almost constant piano playing in the background, except for scenes where tensions are high and the music stops. In the card game scene, a simple melody used to convey the passage of time repeats, paired with shots of the actors peering through their cards, intensifying only when Platon shows his winning hand. In the climactic scene, in which Platon strikes Mariia with a log, we hear Sergei Kurekhin's rendition of Mozart's "Donna Anna," an epic dark synth to the opera singing in heavy vibrato. The reference here to Donna Anna is not accidental. As in the original opera, the character's quintessential role is to rebel against the creator. Of all the films studied in this book, *Gospodin Oformitel* does the most with music to heighten the sense of horror and insecurity.[8]

Platon showing his wild joker

It is debatable whether this film qualifies as "horror" in the classic sense. On the one hand, the story might be seen more as science fiction, and there are no ghosts or vampires lurking around. However, in so far as it depicts the horrific possibility of man's creation turning against him—of "things" getting the better of us—the story does play with the binary of life and death that we are confronted with every day. In the real world there is no in between, but as Grin and screenwriter Yurii Arabov's stories attest, the prospect of a "third way" can only be realized through human endeavor. The objects around us, helping us win, lose, and survive, mediate between the spiritual and the profane. After living for years in an officially atheist state, one that suppressed a spiritual understanding of humanity's place and responsibility on earth, Orthodox believers sought justification and recognition for their belief that something divine must tame the capriciousness of man.

Chapter 4

Toxic Communities in *The Vel'd* (1987)

Whenever someone brings up the late Soviet Union or *glasnost*, thoughts typically turn to the Chernobyl nuclear disaster. On Saturday, April 26, 1986, reactor no. 4 at the Chernobyl Nuclear Power Plant, a control test went wrong, and a large amount of energy suddenly released, leading to a chain reaction that ended in a massive reactor core fire that spread airborne radioactive particles through the region. The disaster was the first of its kind and scale in the USSR, and the first one so close to the heartland of the country with direct international repercussions. In their lengthy book on Chernobyl, Dr Robert Peter Gale and Thomas Hauser write "Chernobyl has forced us to contemplate these issues; to acknowledge that modern technology is a potent force that, when something goes wrong, it's an international event, not a national one."[1] Even the first issue of the satirical journal *Krokodil* for 1987 included a picture of Santa Claus holding up a sign reading "We're against the Nuclear Winter!"[2] Fear of nuclear power was everywhere, especially growing in Central Asia, where the majority of Soviet nuclear tests occurred.

After 1986 and the public and international outcry over the Party's attempt to avoid attention and culpability, the threat of technological disaster and clandestine efforts to mask tragedy seemed more archaic than ever. Chernobyl was a pressure valve that burst open a flood of public concern and criticism.

Soviet people around the country began to question whether their government kept more from them. In Leningrad, for example, concerned citizens and scientists mounted a lengthy and emotional campaign to challenge

the construction of a massive flood protection barrier that they believed would turn the Neva delta and the city's water into a septic tank. Chernobyl was the shot heard around the world that encouraged Soviets from Moscow to Tashkent to question unchecked faith in modern technology.

The Context

For years leading up to the Chernobyl disaster, the Communist Party focused on updating its technological infrastructure in order to revitalize production and innovation to stay on par with the West.[3] After World War Two, the Central Committee recommitted to inspiring socialist construction through big projects in the same way it did under Lenin's electrification campaign, or Stalin's industrialism, but they were dealing with a different generation of workers and socialists.[4] Youth Stakhanovism dropped off precipitously in favor of bone records and hipster fashion. Beginning particularly with Brezhnev, but lasting well after his death, the regime and its successors considered technology to be a way to improve the lives of its citizens through supplying energy and securing property. The state pushed heavily for projects to transform nature, like the Baikal-Amur Mainline (BAM), as a way of revitalizing socialist workers' enthusiasm and increasing the efficiency of transportation infrastructure.[5] The Party believed that such initiatives injected workers with a new sense of purpose and could also be used to demonstrate the efficiency of the state and economy in the era of economic stagnation. Nuclear reactors went up across the USSR, which necessitated the training of a cadre of nuclear experts and testing. However, as evidenced by what happened in Chernobyl, the efforts from above merely hastened the standardization of an industry not yet fully integrated or developed. One of the major problems that underpinned late Soviet governance was the State's merciless push for innovation and expansion

without the cautionary pre-requisites and know-how to make those gains lasting.

Chernobyl removed the metaphorical foggy goggles and tipped off a series of reforms in the Soviet Union, the most important being *glasnost*, or openness. *Glasnost* officially started before the Chernobyl disaster, but the severity of that incident really pushed society to invest in the initiative and hold Gorbachev to his promise. The idea behind *glasnost* was to foster a sense of transparency between the State and the people who felt that the Communist Party knowingly put them in harm's way. As Paul Josephson says in his book about the Soviet nuclear industry, "Chernobyl led citizens to recognize that technology, which they had seen as a panacea for Soviet social, economic, and political problems, was not inherently safe, nor were its operators infallible."[6] The disaster was, in every sense of the phrase, a paradigm shift in the USSR, as the Chernobyl-*glasnost* combination served a one-two-three knock-out to Soviet technological ambitions. Indeed, after 1986, the experience of nuclear disaster and the State's new transparency gave rise to a plethora of local protests aimed at potentially dangerous state endeavors and promethean projects. This was a moment that one historian referred to as the "awakening" of the Soviet Union precisely because it saw an explosion of social movements aimed at the plutocratic, technocratic, bureaucratic Communist Party which seemed hell-bent on producing for the sake of maintaining appearances with the West.[7] Actions ranged from massive demonstrations against a proposed chemical weapons destruction facility in Chapaevsk, to protests over the construction of a dam complex in Leningrad. Whether or not *glasnost* was as pertinent to the collapse of the USSR as scholars like to claim is an issue of debate, but the fact that Chernobyl provided a catalyst for a series of confrontations between Soviet society and older Party technocrats is

undisputed. After 1986 the USSR turned into what sociologist Charles Tilly refers to as a "social movement society," in which a network of issue-oriented activists, united by their collective identity, sought to bring about social change by means of collective agitation.[8]

But fear of disaster did not exist only on a massive, nuclear scale. The pervasive sense of being led down a dark pit of irreversible ecological catastrophe by the promoters of State Communism echoed within the home and material life of Soviet people. Afterall, if the Party proved unable to guarantee safe technological and architectural solutions to real societal problems, then how could anyone trust that their consumer goods or their ideology were any good? Youth consumption became a point of contention within the Soviet press and Party. Since the 1970s, or even earlier, Western music found its way into the Soviet Union through black-market "bone" records and flea-market style shops.[9] By 1986, rock'n'roll was there to stay, and even though Russian bands sought to capture the attention of enthusiasts, the pull of Western music remained. For example, after 1986 the newly formed Leningrad Rock Club admitted previously restricted acts like the punk bands *Avtomaticheskie Udovletvoriteli* and *Grazhdanskaia Oborona*. The turn in youth culture also had a sinister side: with the uptick in nationalist sentiment within the republics, neofascist gangs started to appear, engendered by films like *It Isn't Easy Being Young* (1986), and Gorbachev's call on young people to help root out corruption.[10] Party conservatives sought to discredit Western influence by labeling Western-style youth counterculture and music as "bourgeois," but young audiences did not care about the political connotations of Deep Purple, they just wanted something non-Soviet.[11] The cultural expressions of Soviet youth underwent a massive change beginning in 1986, and many willingly, and often times purposefully, rejected,

questioned, or ignored official discourse and culture.

Essentially, a twofold shift occurred in the relationship between society and the state after 1986. On the one hand, the people refused to blindly accept or go along with enormous technological projects as a way of demonstrating socialist progress. On the other hand, certain sectors of society, such as the youth, dislodged from the ridged cultural forms imposed from above.

The transformative nature of this moment in Soviet lived experience and history is vital to understanding the emergence of horror as an approved film genre. As Josephine Woll points out, "Horror films of every provenance and time period typically involve the penetration of personal space."[12] It's certainly true that in early Soviet cinema and horror, the sense of personal violation is omitted in favor of standard abnormal characters like witches and ghost riders. But beginning in the mid-1980s, with the proliferation of "not in my back yard" activism, what was once transgressing the collective turned increasingly communal. To continue the example, in Leningrad, the appearance of algae blooms and stagnant waters due to a dam in the Gulf of Finland not only upset local ecologists but violated locals' sense of water security.[13] At the same time, the adaptation of Western countercultures by the youth no longer concerned the collective community exclusively but started to transform individual households more fundamentally. Even on a personal level, the spread of nuclear particles in the air threatened private comfort in an unheard-of way. All around the USSR, what would once have been branded collective issues started to instigate more pervasive individual anxiety and concern. The decision to mobilize—to participate in direct actions within one's city— derived from personal experience and anxieties first, and responsibility to the collective well-being second. The Soviet socialist order of things had changed forever.

The Narrative

It's not so surprising then that a story by Ray Bradbury appeared on the big screen in 1987 as the first official Soviet horror film. Known as a writer of horror and science fiction, Bradbury's dystopic tales matched the post-Chernobyl sense of technological apocalypse and rejection of normality. The Veldt is one of those stories that captures everything despite its small size: horror, suspense, technological insecurity, and even multiculturalism (in a way?). It has been adapted many times, beginning in 1955, but especially throughout the 1980s, following the chronology of socially transformative decades as it appeared. What is most interesting about the Uzbekfilm version is the way that director Nazim Tuliakhozhaev interspersed several Bradbury storylines within the core Veldt narrative, making the Soviet version a truly time-tailored cultural artifact.

Bradbury's story takes place in a technologically advanced "Happylife Home" that can change the sensory elements in any room. The narrator makes it clear that the Hadley children are spoiled, and the parents, Lydia and George, are not engaged in their domestic responsibilities. In the beginning, Lydia expresses concern with the nursery, which the children have changed into an African safari, replete with lions and a single African Veldt. When they enter the room, they experience a projected reality that is more real than projection, and it troubles them so much that they implore the children to change it. The children refuse and are in fact so entranced by their Veldt setting that the parents begin to feel like the house is taking over their authoritative role, and their children's reality, making the parents' presence entirely unnecessary.

After enduring the potential danger and annoyance of a real lion in the house and disobedient children, George decides to act by threatening to turn off the house. Refusing

to feel redundant by his children, he proclaims, "Children are carpets, they should be stepped on occasionally." But despite his determination to persevere, there's a sense that the room is alive and capable of making decisions autonomously. Thus, when George unplugs the room, his children let out hysterical cries. Bradbury writes, "The house was full of dead bodies, it seemed. It felt like a mechanical cemetery. So silent. None of the humming hidden energy of machines waiting to function at the tap of a button." With such a dreadful atmosphere and children in hysterics, eventually Lydia and George are convinced to plug the house back in. Moments later, the children call for their parents, who run down to the nursery to check on them, and as they enter the room, the door is slammed behind them, rendering them feed for the virtual lions.

The Film

Tuliakhozhaev's film begins with a strange, disconnected jousting match between two knights in the woods. Suddenly, we are introduced to two men on a train who throw an apple to an old peasant-looking man who is visiting the grave of his long-dead son. In this way, Tuliakhozhaev instantly draws a contrast between the old folkish countryside, where people innocently grieve for their dead, and modern urbanites whose care for others doesn't go beyond a charitable apple. We learn that the peasant man has lost a son at a very young age, and that his wife grieves so much that she lost her sight. From the woods, they hear the ferocious roar of a lion, which provides the connecting thread between the pitiful family and the Veldt story. The camera moves to show what appears to be some kind of industrial factory before landing in the "Happylife Home." In that way, the introduction immediately establishes a transgressive juxtaposition between time and space—between the rural peasants who grieve silently, and

the hysterical urban parents in the smart house.

The Hadley narrative in the film stays close to the Bradbury original, but there's some technical additions and narrative connections that make it stand out. For one, the camera moves as an independent actor, almost like the technical spirit of the house, floating from a point of view shot through the halls and into the bedroom of the Hadley's (think Evil Dead). As the story emphasizes the autonomy of the house, the film uses camera techniques to demonstrate the same, and to suggest that it is active even while the family sleeps. That means that the viewer always assumes the character behind the camera is alive, much like a nuclear power plant, and Tuliakhozhaev is not afraid to use that assumption to play with our fears.

We don't see the children until almost 20 minutes in, after the father has a patriarchal meltdown. Interestingly enough, the mother incurs the wrath of the son the most, and his attitude toward his parents can only be described as indignant. There's a deep psychiatric tension within the household between the family members that the original story struggles to convey, and it stems in part from the parents' unwillingness to raise their children. Most of the initial shots of the parents are in the bedroom, absorbed in their own narcissism. They have relegated all responsibility to the household, but now the household is acting for itself, and the parents feel the walls caving in, for lack of a better metaphor. The alternate reality created by the children provides a space and setting that keeps them happy and engaged, despite the parents' agitation, much like the subcultures that courted the attention of Soviet youth at the time.

The parents inside the virtual safari room running from a lion

Outside of the house offers no reprise from the horrors that are inside. As George walks outside, he sees people in hazmat suits dragging what appear to be bodies into militarized ambulances to be carted off to some unknown place. Every depiction of these gas-masked phantoms calls to mind images from Chernobyl, as it appears some kind of radioactive scourge has ravaged the city. George's doctor friend later explains that those are not human bodies being dragged, but apparitions that look like dead loved ones and friends. Tuliakhozhaev's decision to set the narrative within this broader Frankenstein motif of resurrection-gone-wrong made the film less about the Hadley household and more of a systemic criticism of science unhinged. The threat of technological progress thus exists in both settings of the film. The Happylife Home is supposed to be relief from the horrid realities outside—technology providing relief for the problems of technology—but it's only causing a rift between parents and

children. Outside, the risk is more evident: human progress and science has created an inhabitable zone where people must suffer the loss of a loved one twice.

Hazmat people dragging a corpse

The experience of the Hadley family contrasts with the old peasant family who both live outside the city and outside of a Happylife Home. They grieve heavily for their son who died at least 30 years ago, suggesting that they cared deeply for their child in a way that the Hadleys never felt for their children. The mysterious force of the Happylife Home is also at work on the innocent family. Reminiscent of Harry Bromley Davenport's *Xtro* (1982), the phantom force brings these innocent peasants their son who defensively commands them to not ask any questions about his reappearance. One can read this as an analogy to the USSR's relationship to science: progress comes, but the cost of progress is shielded from the benefactors. Basically, a Faustian

deal where you get what you wish for, but it might not be exactly as you imagined it.

The old man embracing his returned son

There are thus three threads emphasized throughout the film: neglectful parents, over-reliance on technology, and indignant children. Tuliakhozhaev wants us to believe that technology has a life of its own, and when not respected or properly utilized it can destroy entire societies and households, including emotional relationships and expectations. For Tuliakhozhaev, an ethnic Uzbek who witnessed the literal draining of the Aral Sea by the Soviet Union, the horrors of technocratic caprice are self-evident, and Bradbury's tale makes it as personal as possible. The terror of this film is both familiar to Western audiences in its use of jump scares and intensified music, and unfamiliar in the way that is really draws on the intersection between technological change and family relations, an experience that resonated with

families undergoing a fundamental transformation of the public and private spheres and feeling the effects of environmental change at home.

Contextualized within the late USSR, particularly only a year after Chernobyl and the initiation of *perestroika*, *Vel'd* is a call to people across the country to stay skeptical of technology and the effects it has on family members. If the promise of the future is to make life easier in the form of robotic houses, the story reminds viewers that certain things will always require special care and human attention. Technology that is allowed to run rampant will turn children against their parents and render soulless lifeforms of our loved ones.

Generational Conflict in "Fear of The Vampire Family" [*Sem'ia Vurdalakov*] (1990)

One can glean a lot from the titles of monographs about the final years of the USSR: *Roads to the Temple*, *The Last Empire*, *Everything was Forever, Until it Was No More*, *Lenin's Tomb*, and *Age of Delirium, She Fell Apart* [*Ona razvalilas'*] to name just a few. These titles suggest a profound sense of loss and insecurity of the future, but a prescient sense of the moment in time. It did not take the constant reinforcement of *perestroika* and *glasnost* to make it clear to people that change was afoot in the USSR. Especially in 1989 and 1990, while Baltic German states started to declare independence, thanks mostly to popular nationalist movements, Russians recognized the magnitude of what was happening around them but wondered what their own future had in store and who would determine it.

The Context

When it comes to the transformations underway in Russia, there are a lot of potential variables to consider. A social body is never as cohesive as one might wish; it's made up of various generations with different lived experiences, and emotions that can't always be expressed in words. These elements were intensively felt in Russia between 1989-1991, as the older generation came to symbolize and, in some cases, defend communist conservatism—a urge to return to pre-reform Party discipline and control. News from around the world and a plummeting economy left adults without the lexicon or time to express their profound anxieties. In the middle of these two poles stood a new generation, whose future was subject to a tug

of war between the adult parents seeking to make ends meet in a rapidly changing world, and grandparents who often thought change too dangerous and ignorant of their sacrifices.

On a national scale, Russia in 1989, after the revolutions in Poland, East Germany, Bulgaria, and elsewhere, and with its increasing rivalry with the USSR, found itself at a crossroads. On the one hand, Communist Party reformists and new democratic *neformaly* wanted to continue and even extend the new freedoms granted by *perestroika* and *glasnost*.[1] On the other hand, conservatives, mostly older members of the CPSU, sought to rein in the reforms, feeling as though they had grown grossly out of control. The question for those in power was how to reform State Socialism without collapsing the Soviet state apparatus entirely. For the Party apparat, the answer was science and technology; if cultural concessions are granted to society, then the initiative for innovation and research would come from below.[2] The one caveat, though, is that, as Marx argued, people typically act in what they perceive to be their own best economic interests, and by 1990 the Soviet economy was virtually non-existent. Production, labor, and capital were no longer abundant, and the Soviet economic machine seemed unable to keep up with the influx of Western culture and influence, embodied symbolically and literally by Coca Cola and blue jeans.

All of these reforms were understandably a lot to handle for Soviets from age 5 to 70. On the one hand, Soviet baby boomers were in the midst of witnessing the implosion of their home country, an experiment they had worked on for their entire life. Imagine, for a moment, the country you grew up in disappearing entirely without any referendums or say from you or anyone else on the ground. They realized that the promises of realizable socialism in the Brezhnev years amounted to nothing, and rather than accelerate socialist construction, the noticeable differences in the quality of life and consumer

opportunities by 1987 between East and West rendered Soviets passive benefactors of a bloated bureaucratic Party-state. Those born in the late 1960s and 70s, many of them parents by 1990, waited in long bread lines and worked tirelessly to support their families.[3] Grandparents were often the daytime caretakers of children born in the 1980s, who grew to revere their *babushka* and *dedushka* and respect their experiential wisdom from having lived through the Thaw, the Era of Stagnation, the changing legacy of Stalinism, the revolution in consumer goods, and the Nazi invasions and blockades. The children of this "great generation," the Soviet equivalent of baby boomers, interpreted that experience in a different way: if anyone could be blamed for their economic conditions, for deviating from orthodox Leninism, it was their parents, the nomenklatura, the bureaucrats.[4] A paradox existed in the final years of the USSR, where young adults had to defend their new freedoms from a generation that their children paid homage to.

Take the story of Fedor "Feddy" Lavrov as a case study. In the early 1980s, before he became known as the Soviet Union's first Anarcho-Punk, Feddy used to tune in to intercepted BBC news and Voice of America radio transmissions with his grandmother. He did not understand much of the news, but he understood that it was important enough for his grandmother to regularly get the scoop from non-Communist news agencies whenever possible. When she was done, Feddy remained behind to listen to Western radio hit singles, imagining the dress and lifestyle of rock musicians. For a kid that age, Feddy did not understand why he could not have unfettered access to that music and style, but he knew his beloved grandmother was an avenue to another world while his mom was away working, and his father was absent.

The Narrative

There's little wonder that *Sem'ia Vurdalaka* (1990) seems like

such a timely horror story to adapt to the big screen. Originally written by Aleksei K. Tolstoi, the second cousin of Lev, the story[5] concerns the fate of a family haunted by a vampiric grandfather who first seduces the grandchild into his nightly charades. The entire story also has a nationalist angle: the narrator, a French Count D'Urfé, tells the story to a group of *mesdames* as the 1815 Congress of Vienna wraps up. The Congress of Vienna, like the collapse of the Berlin Wall, signified a monumental change in the chessboard of Europe: Napoleon retreated in shame from Eastern Europe, as horses and men fell by the wayside, and Emperor Aleksandr I followed in hot pursuit until the Russian Army marched into Paris, effectively ending the Napoleonic control of Europe. French control of the continent dissipated, and Russian suzerainty emerged, but the powers of Europe did not want an unleashed Russian bear reigning over the East. Thus, Tolstoi's story is one of anxiety, where the personal fate of the protagonist is just as murky as the destiny of the French empire he identified with, not to mention Tolstoi's own anxieties over his Russian identity.[6] The East is a place of horror and enchantment for the Frenchman, while the comfortable society villa from where D'Urfé tells his story is far from the "barbarous" vampires of the Slavic world.

D'Urfé prefaces his story by saying that it is equal parts horrific and romantic, because "the romance is an essential part of the narrative." Before leaving for Eastern Europe, he is given a cross by the woman he loves as a memento to remember her by. One day, he stops in a Serbian village, where a man invites him into his house. Sadly, the count arrives as the family mourns the loss of their grandfather, Gorcha, who went off to fight a Turk named Alibek. Before leaving, the grandfather warned: "If I don't return by the tenth [day], have a mass said for my soul because I'll be dead…But if I come back after ten days, for your own sakes do not let me in."

Well, you can guess what happens. The grandfather does

return after 10 days, only he's not exactly the grandfather that everyone knew. That doesn't stop the youngest character, the boy Pierre, from asking where Grandpa is, and why nobody is allowed to talk about him. Not only does the boy unwittingly summon Gorcha the vampire, but he is also the first victim. In one haunting passage of the book, the protagonist hears the boy playfully talking to the undead grandfather from the window in the dead of night.

On the romantic side of things, D'Urfé claims that the father's sister, Zdenka, looks exactly like his love in Paris, so much so that he falls completely in love with her, almost as though a superior force compels him. At one point he goes so far as to offer her his life and blood for her affection, which, you can imagine, comes back to haunt him. These romantic encounters are broken up by the repeated penetrating eyes of the dead grandfather, who D'Urfé spots peering through the window. Eventually the protagonist sees the young boy being led into the woods by the grandfather and erratically wakes up the father, George. As most fathers would, George jumps out of bed and runs into the woods after his son, returning pale as snow only after dawn. Rather than explain where the boy went or what he's done, George pulls D'Urfé aside and urges him to return home. Conflicted over the love he feels for Zdenka, D'Urfé remains awake all night weighing whether to leave his love, but his attempt to embrace her is blocked by George. The next morning D'Urfé departs to his final destination as instructed, leaving the family and his love to their fate.

Sometime later he is recalled to France and decides to take the same route home. He hears the church bells from the village and stops at a nearby monastery. Once there, one of the hermits tells him that the entire family became vampires, and Zdenka went mad with grief. Unable to restrain himself, D'Urfé rides to the house and enters an abandoned cabin. He falls asleep on Zdenka's bed, only to awake to her in the room. They have

a romantic back-and-forth, but he slowly begins to realize that Zdenka is not the same innocent girl he knew. As if her pale complexation and cold body aren't enough, D'Urfé realizes Zdenka is actually dead when she resolutely denies a small enamel cross that he tries to give her. She begs him to stay, reminding him that he promised his blood, but as he embraces her, he sees Gorcha and George approach the house through the window, suggesting that it was all an elaborate trap.

As the vampires close in on him, his romantic advances continue, but this time his goal is to try and recruit Zdenka to somehow help him escape. "Then...there occurred one of those mysterious miracles that I cannot explain," D'Urfé tells his listeners. As he embraces Zdenka with a passionate hug, the cross around his neck pierces his skin, and he looks up to see a stiff featureless body. Rather than freak out, he pretends not to notice so that he can slip out the door undetected. He runs through the woods, dodging flying vampire kids along the way, but eventually makes it out alive.

An earlier film adaptation of this story appeared as a short in famed Italian director Mario Bava's 1963 film *Black Sabbath*, with Boris Karloff playing the leading role. In that film, the directors stayed close to the original story. The darkness of the tale matched the aesthetic of Bava's films well, and its choice for that time and place has no obvious meaning besides the fact that it is one of the first popular vampire stories in Europe. There is also the 1972 Italian and Spanish loose adaptation by Giorfio Ferroni, but it diverges from the original story so much as to be nearly unassociated.

The Film

In the 1990 Russian adaptation, the story is changed a bit, but the core threads of horror and romance remain. The first film by directors Gennadii Klimov and Igor Shavlak, who also stared as Igor, the movie's equivalent of D'Urfé, was a popular TV

special for its time even though reviews of it are almost entirely negative.[7] Elena Karadzhova plays Mariia (Zdenka), Nikolai Voloshin does a thrilling job depicting Iakov (Gorcha), Nikolai Kochegarov plays Georgii (George) and Ivan Shchegolev plays the young boy.

As a production-level sign of the times, the film was not produced by one of the major film companies, Mosfilm or Lenfilm, but rather an independent agency called "Aist." Aist received funding from the Red Cross and the Red Crescent of the USSR to raise awareness of the AIDS epidemic.[8] Hence, the vampiric theme of blood contagion meant to make viewers aware of the dangers of spreading contaminated blood. The directors' decision to set the story in modern times also represents an attempt to make the topic relevant for their day. However, the slow privatization of the film industry meant that many producers lacked the necessary funds to create high-level films, and the film's low budget can be seen in the poor recording and lighting technology. Still, if we're in it for the story and the symbolism, this film has a lot to offer.

There are a number of places in which the film diverges significantly from the story, but two are worth emphasizing for what they symbolize about Russian life in 1989-1990. For one, the main character's literal passage through time from contemporary Moscow to the archaic rural atmosphere of the vampire village captures the lingering tension between the past and present that underpinned late socialist society. This phenomenon was felt both on the ground, by the flowering of youth counterculture, *neformalny* groups, and alternative lifestyles, and on the state level, where reform-minded communists looked toward Lenin as a guide back to Communist orthodoxy.[9] The moral, financial, and political consequences of change scared people most, and Russians had to ponder whether the offerings of the present outweighed the promises of the past. As Sasha "Chacha" Ivanov of the band Naïve said, "We hated the Soviets; they

were fucking assholes. They didn't let us play punk rock, drink coca cola, chew bubblegum…imagine a reality in which you don't have these things. You see them in movies, but you can't buy it, because nobody is selling it."[10] Hence Soviet youth did not hesitate to rebuke communist ideology if it meant gaining access to commodities like they had in the West. However, the most chilling element, and the most particular to this film, is the demeanor of the characters, the relative silence of the actors, and the film's ability to express emotion through what's being heard and seen rather than said.

While Tolstoi's story emphasizes a spatial dimension between East and West, the film moves back and forth between the past and the present, between modern Moscow and an archaic village. Igor enters the village through a river covered with fog, almost as though passing through to a liminal zone, a temporal threshold. Once there, he immediately walks through an abandoned monastery with decaying façades and walls, representing a place completely forgotten by time, and referencing Tolstoi's original story. The camera depicts people using old world technology, such as horse-drawn carts, and immediately cuts to Igor's modern camera. Igor's inability to take the somber atmosphere seriously is most felt when he mocks the backwardness of the place by sticking his tongue out in the mirror when unpacking, and when he fiddles while the rest of the characters pray before dinner. The directors really focused on depicting Igor as a photographer of the dead with a smug attitude, over-confident, with a modern aversion to the sacred and paranormal. But the gothic atmosphere of his entry into the town suggests that he's never really had to confront the dead. It's a metaphor of a new generation of Soviets confronting their past without having lived through it: while Soviet boomers could boast of growing up with the World War Two generation and those who experienced the terror, Igor's generation, born in the Brezhnev years, only knows what they've seen through

photographs and stories—secondhand experience.

Igor mocking the family mirror

The other plot device driving the depiction of temporal tension is the portrait restorer that Igor meets before he leaves for the village. There is no portrait restorer in the original story, but in the film an old man is used to represent the restoration of an unknown past, which brings us back to the proliferation of preservationist groups and the troubled endeavor to resuscitate Leninist theory. He tells Igor that he is not an artist, and he refuses to let him see the portrait he's currently working on. The old man at least has the artistic ability to join the past and the present, while Igor merely captures images with his camera. The difference in purpose is important: preservation for the sake of memory dictates the job of the old man, while capturing and commodifying drives the actions of Igor. We are supposed to see wisdom in the restorer, in contrast to the nativity of Igor. The juxtaposition between Igor and restorer is a cautionary embrace: "you may want to photograph the dead,

to churn out photos of what's passed for your employer, but you should do so with reverence, least the dead—the past—bites back."

Finally, and most hauntingly, the vampiric grandfather literally personifies the past in that he is the elder of the household, and he is dead. As Stephen Lovell argues, older Russians in the post-World War Two era exercised social authority in the nuclear family, which boasted about two-thirds of households by 1979.[11] After all, they were the last generation to score a major victory for socialism against a formative external force (Nazism), not to mention withstand sieges, famine, and invasion. But in the final years of the USSR, the sacrifices they made seemed to be giving way to a new reality of cultural exploration, all while their disproportionate responsibility in the household remained the same or increased. After 1970, the older generation of Soviets on their pension became increasingly responsible for social necessities like educating children at home and household chores, while young adults spent their time building careers in new technological or scientific fields. Indeed, contemporaries have fond memories of their grandparents and the special sense of security they felt under their protective wing. As Victoria Semenova and Paul Thompson write, "It is very striking how much more often there seems to have been a confiding intimate relationship between the child and its grandmother than with the parents."[12] Because grandparents were the most vital to child rearing in the later years of the USSR, the possibility of their transgression or betrayal remained one of the most pervasive vulnerabilities for the nuclear household. That lingering insecurity explains why elderly people play such sinister roles in late Soviet horror cinema. Between *Sem'ia Vurdalakov* and Evgenii Iufit's *Papa, Umer Ded Moroz*, film writers and directors sought to exploit the vulnerability that came with such a ubiquitous grandparental influence on the future generation of leaders.[13]

Iakov, the grandfather in *Sem'ia Vurdalakov,* is the character that leaves the adults speechless, although his presence is commanding and his voice thunderous. The scene where the family sits around

the table in silence is the most illustrative of the point. Before the grandfather enters, all we hear is the musical score, which is clearly an attempt to mimic music from Western horror, and an unescapable sound of howling wind in the background. The characters Igor and Mariia exchange glances, but everyone seems tongue-tied as though they have no words to express the events happening around them. Finally, the naive little boy characteristically breaks the silence by asking "Mom, where is grandpa?" thereby summoning his spirit. The boy's outburst represents the innocence of the young generation, too simple to understand the consequences of what is going on and doggedly loyal to their caretakers. To further the comparison, imagine if Feddy's grandmother disappeared: what would happen to his access to retro music, and who would he have to ask her whereabouts other than his mother? In this scene, the film is toying with the reverence that children feel for their grandparents, preparing the viewer for the horrific realization that the boy's trust is misplaced.

Iakov the grandfather enters the house and sits at the table in silence

Hence, the scariest part of the film is when Iakov opens the boy's bedroom door and asks, "Are you asleep, young one?" The boy looks up lovingly at his grandfather, who invites him outside where there is a new toy saber waiting for him. As sanguinely as Feddy would look at his grandmother and take her hand, the boy agrees to go outside, and the two are seen by Igor walking into the woods. To Soviet audiences at the time, the scene was so visceral because it depicted a breach of trust between the grandfather and parents, and between the grandson and grandfather. The boy's naivety is used against him by the witty undead for its own self-interest, and the worst fear of the parents comes true: the boy falls under the dangerous influence of the vampiric grandparent not by spell or trick, but by simple love and reverie.

The young boy looks up lovingly at his grandfather

Understanding this context and interpretation does little to dispel the lesser qualities of *Sem'ia Vurdalaka*. The negative reviews are right to point out the film's disconnected parts, poor quality, lackluster acting, and over-ambient atmosphere.

There are a lot of technical missed opportunities in this film. For instance, the creative directors decided to leave moments of heightened tension silent, with nothing but howling wind and natural sounds in the background that do little to hold attention. While in theory this gothic strategy does create an eerie sense of realism, it also makes it hard for the viewer to follow along. Leitmotif is one of the most important strategies for suspense building, and while the directors seem aware of this (note the part where George's corpse opens its eyes before Iakov's fall), most of the moments of suspense are left silent. Hence, the atmosphere remains stale.

Regardless of creative decisions, the argument here is that the film cannot be judged without taking into consideration its time and place, and what the various sub-plots may have meant for Russians at the time. Of all the films discussed in this volume, it might be the most symbolic from conception to publication. Russia in 1989-1990, as in 1814, was an anxious society in which the future well-being of the state and the household depended on the resolution of tensions within the nuclear family. *Sem'ia Vurdalaka*, for all its faults and missed opportunities, conveys that social fear familial tension riddled by contradictions in time finally reaching a breaking point. It's not difficult to draw an analogy between literal vampires and the vampirism of the conservative communist leaders who threatened to suck the vitality out of a society that had just gained exposure to independent organizing and western culture. As we'll see in the next chapter, the motif of vampirism carried various historical and social meanings for late Soviet society.

Chapter 6

Women as Late Soviet Bloodsuckers [*P'iushche Krov'*] (1991)

Vampires were everywhere in the final years of the USSR. Well, maybe not literal vampires, but metaphorical vampires certainly lurked in theory and on the screen. In addition to *Sem'ia Vurdalakov* and later films like *Zhazhda strasti* (1991), *Papa, Umer Ded Moroz*, and *Vashi pal'tsy pakhnut ladanom* (1993), the vampire motif of blood-sucking undead night crawlers with an uncanny ability to enchant their victims pervaded the emergence of horror films toward the total collapse of the USSR. Most of these depictions derived in some way from Aleksei Tolstoi short stories, and there's no surprise that as Russians sought to explore the genre previously considered taboo, they looked to their own literary history for guidance. But director Evgenii Tatarskii and writer Artur Makarov's 1991 *P'iushchie Krov'* paints an altogether different picture of the craving coffin dwellers that illuminates the amorphous application of the vampire metaphor in their time.

The Context

As anyone who has read Marx probably already noticed, the metaphor of vampirism as capitalistic socioeconomic leaches is a time-tested pedagogical tool given to us by Marx himself. In his magnum opus *Das Kapital*, Marx describes capital as "dead labor, that, vampire-like, only lives by sucking living labor, and lives the more, the more labor it sucks."[1] Marx loved the vampire metaphor and images of the undead, going on to describe factory owners' "vampire thirst" and using that image throughout his most important writing, including the *Eighteenth Brumaire of Louis Bonaparte* and *Grundrisse*.[2] The common interpretation

of Marx's usage understands the factory owner or capitalist as the vampire, sucking the surplus value from the laborer until they are a lifeless corpse fully under its spell. In this reading the vampiric undead contrasts with living labor before it becomes a passive victim. Capitalistic nosferatu then strips the victim of their humanity, rendering a lifeless corpse, falsely conscious of their role in the system.[3]

Still, there has been much debate over the exact meaning of the metaphor, with some scholars distinguishing between "dead labor," i.e., lifeless machines that embody labor of the past, and living labor. Another scholar notices Marx's changing use of the vampire metaphor to describe *capital* at one time, and *capitalists* at another time.[4] What they all have in common is that they recognize the vampire as a rhetorical tool to establish a binary between a parasitic group on the one hand, and an innocent bystander or worker on the other. Understandably, this is the broadest possible metaphorical interpretation one can apply to vampires, but it is one that allows us to accept the variety of interpretations as equally valid. This chapter is less concerned with finding a more exact interpretation of Marx's use of the metaphor, and more focused on demonstrating that vampires lurk within Marxist thought, and thus Soviet parlance.

Vampires were no strangers to Soviet citizens, particularly the parasitic aristocratic-cum-bourgeois type. Take for example Lenin's so-called "hanging order," where as early as 1918 the progenitor of the USSR called for the execution of rebellious "kulaks, the rich, and the bloodsuckers [*krovososov*]."[5] Even in 1967, when the witch from *Vii* summons the beast, she chants "come to me vampires [*upyri*], come to me bloodsuckers! [*Vurdalakii*]." Again, in the late Soviet Union, when critiques of Soviet history became more prevalent, writers used the image of the vampire to describe how ruthlessly the state pushed collectivization.[6] These traditional uses of the vampire image reflect a country willing to employ Marx's metaphor in its

binary sense, as an embodiment of socioeconomic and moral evil in contrast to the innocent. But as this chapter argues, in depicting the traditional aristocratic vampire, the creators of *P'iushchie Krov'* actually reified an older and more pervasive vampiric archetype—the sycophantic female.

The binary interpretation as it relates to moral condemnation is not an altogether new idea when it comes to vampires and ghouls. As scholars of horror literature and film have pointed out, the vampire frequently serves as an "other," a scapegoat, who disrupts not only the normal flow of blood, but of life and events themselves.[7] Thus, vampires have been interpreted as "cosmopolitan" Jews and homosexuals alike—anyone who deviates from white Christian male heteronormativity.[8] The oldest depiction and most understood, however, is the vampire as female, where the blood lust and deceitful hypnotism represents female sexuality. In fact, as Tony Throne demonstrates, the earliest literary vampires were in fact women, and much like the use of witches, men used vampirism to single out women for what they defined as sexual promiscuity and transgressive morality.[9] Over time, though, and particularly thanks to Bram Stoker's *Dracula*, the image of soul-sucking society women gave way to the aristocratic male vampire, which has dominated popular lore sense. What is so paradoxical about the film *P'iushche krov'*, in that case, is the way that it reinforces the female vampire stereotype in an aristocratic setting at a time when women in the USSR bore the brunt of socioeconomic and political transformations.

Considering the history of the "woman's question" in the USSR, there's no surprise that the contradictory depiction of women in *P'iushche krov'* went over the head of Tatarskii and Makarov. Beginning in 1918, Lenin recognized that women under capitalism were in abject domestic slavery, and only socialism could liberate them.[10] From then on, men in positions of power continued to dictate the relative "liberation" of women

concerning their bodies and employment, especially during the Stalinist years. With the new freedoms afforded by *glasnost*, women began to call out the obvious contradiction of theory and practice, using the new state policy of openness to publicly voice their dissatisfaction by challenging the Party's approach to the *zhenskii vopros* [woman's question] and creating a number of women's-rights or all-women's interest groups.[11] But as Elizabeth Waters argues, instead of accepting the criticism of their contradictory position on women, Soviet leaders, and probably Soviet men more broadly, attributed the blame of state Socialism's failures to a slippage in female morality. Waters points out how newspapers and periodicals during *perestroika* published a plethora of articles that condemned "women of loose morals."[12] Neither the Soviet state at its genesis, nor at its moment of restructuring, provided the truly equitable status that women hoped for.

The idea that women struggled most in daily life even during *perestroika* is not surprising given their "double shift" as full-time workers and full-time housekeepers. The economic consequences of *perestroika* in the form of rationing and price increases put an extra burden on women's responsibility as domestic consumers. New political freedoms offered women a chance to be nominated to local office, and even their calls for liberation at times intersected with nationalist cries outside of Russia to break from the Soviet Union. But, despite the hardships and new possibilities, the male gaze remained as firm as ever, with issues like abortion rights and equitable income being subject to the scrutiny and caprice of men in power. It cannot be stressed enough that women undoubtedly suffered the most from the consequences of economic, social, and political transformation.[13] As a relevant example, when Tatarskii sought to cast Marina Vladi to play Marfa Sergeevna Sugrobina, the leading maternal and vampiric figure in the film, instead of paying her he merely paid her agent and promised her she

would play Catherine II in a future film. As an excuse he cites a lack of funding from Lenfilm, which makes some sense given the time, but assuming that all other cast and crew members were paid, Tatarskii's willingness to have a major actor work pro-bono is revealing of the relative ignorance of gender disparity in the workforce, and a broader expectation that women should and can bear the brunt of fledging film financing.[14] Vladi never had the chance to work on a film with Tatarskii as Catherine II because of the collapse, but she did assume that role with a foreign studio.[15]

Evgenii Tatarskii was a star director for Lenfilm studios in his later career, climbing the ladder of positions following his initial entry into that studio in 1964. Most notably, in 1977 he directed "The Golden Mine," a massive success for its time that put him on the path to regular work in Lenfilm's television studio.[16] Tatarskii always admitted that his writing abilities were less than sub-par, so he relied on friends to provide screenplays. The screenwriter of *P'iushche krov'*, Artur Makarov, has a more difficult backstory. The adopted son of screenwriter Sergei Gerasimov and actress Tamara Makarova, Artur grew up within the world of theater and writing, flaunting his acquaintance with cultural icons Vasily Shukshin, Vladimir Vysotskii, and one of the USSR's most famous directors, Andrei Tarkovskii (*The Stranger, Solaris*) among others. Friends describe Makarov as a romantic who enjoyed solitary activities like hunting, which led him to frequently contemplate the passage of life.[17] Although we cannot know for sure what inspired Makarov to choose Aleksei K. Tolstoi's story at this moment, it may be inferred that his familiarity with life in high society, coupled with the appeal of phantasmagoria in the late USSR, made the vampire story about reality and delusions particularly appealing.

The Narrative

To gain a sense of just how prescient the film is, we must first

compare it to Aleksei Tolstoi's original story, "*Upyr'*." Tolstoi's story contains all the same characters of the film, and most of the same actions, but the emphasis and visual techniques make the film's message slightly different. The story recounts the experience of Aleksandr Runevskii, a young man in search of true love. At an elegant ball he encounters an eccentric fellow by the name of Rybarenko, who reveals to him that most of the people in the room, especially the Countess Sugrobina, are vampires. Runevskii, intrigued by what he is hearing and attracted to one of the young women around Sugrobina, pursues closer relations with the family despite the warning. As he cozies up to them, he reveals what Rybarenko said, but the family casts it off as the ravings of a madman. Yet, throughout the story, he learns through a series of lucid nightmares that Rybarenko may not have been as mentally deranged as the Sugrobina household painted him to be. In the original story, Rybarenko's warning to Runevskii can be read as an attempt to divert the protagonist's attention to protect his own interests, as we later learn that Rybarenko is the illegitimate son of Sugrobina, potentially harboring some resentment toward her and the family.

Countess Sugrobina's bloodlust is driven less by her sexual prowess and more by a genuine fascination with the violent past of her late husband. Throughout the novella, her commentary always begins and ends with a reference to the past, especially the warrior deeds of General Sugrobin who slayed hundreds of Turks in his southern war campaigns. In fact, the Madame seems entirely unable to hold a conversation without reverting to her husband's blood-soaked campaigns. Her aide, Semën Teliaev, is likewise pegged as a vampire by Rybarenko, albeit one that more obviously signifies his affliction by smacking his tongue on the roof of his mouth frequently—an impulsive sign of thirst that separates him from the more well-concealed women. Indeed, the aristocratic ladies are the primary actors in this tale, but an important distinction between it and the

film is that men bare sole responsibility for crossing the realm of the living and the dead. General Sugrobin, an Italian count named Don Pietro, and Runevskii himself all impose their condition on women, rather than suffer from women. Even Teliaev's tongue-smacking is the only indication of vampirism in the real world, a disorder that forces him to exist in both worlds at once.

There are numerous interpretations of Tolstoi's story. In so many words, vampirism appears all at once as a metaphor for people who gossip, the way that social types gather information about others in order to sustain and promote their own position. This partially explains Rybarenko's spreading of the vampire rumor right in the beginning. Social death in that case is akin to the literal death at the hands (or teeth) of bloodsuckers. Two scholars have also argued that the story is mostly about the morality of the living invading the arena of the dead, and the ethics of doing so. They argue that the story is principally about boundaries all at once between the characters, between the dream world and reality, and between life and death.[18] Hence, in classic gothic fashion, we are told a story within a story within a story, contravening the standard narrative structure and forcing the reader to cross temporal and spatial boundaries all the while. At one point we are in aristocratic Russia, and in the next we are in a dream someone is having in an Italian mansion.

Tolstoi's use of the vampire mythology is ghoulish in content with suggestive metaphoric implications related to war, trauma, and Western Europe's unease with the foreign East. Even the title *Upyr'*, although commonly translated as vampire, can mean ghoul or bloodsucker, and it definitely contrasts with his use of the term Vurdalak in the story discussed in the previous chapter. Souls exist trapped in portraits, people commit heinous acts in their sleep, and the entire reality of the family's vampiric existence is thrown into

doubt at the end of the story, but their ghoulishness remains. Although an objective understanding of what Tolstoi meant to convey is impossible to ascertain, it is obvious that he wanted to highlight the supernatural and the possibility of the dead walking among us, as well as the morbid glorification people like Countess Sugrobina feel toward people like her husband who were responsible for ending countless lives. On a broader level, Tolstoi wanted to parody Russian aristocratic culture, made up of social and cultural leeches.

The Film

Given that emphasis is put on the action of men in Tolstoi's story, it's curious that Tatarskii's film centers on the women in the plot and draws a stark contrast between virtuous men and manipulative women. The famous director does this with the use of plot devices that utilize the conventional leitmotifs and editing cuts of Western horror. By this time, it can be said that Soviet directors absorbed the cinematographic strategies of minor scale musical leitmotifs and ethereal shots that are heavily cut, slowed down, and blurred to create a sense of distortion and illusion. In the final scene, when Runevskii discovers the reality of the vampire cult, the same leitmotif plays, but shallow shots go out of focus, and the camera angle moves between Runevskii's perspective, the vampires looking down at a peasant woman's body, and a third person view of a cat and rooster, two animals associated with the paranormal in Russian folk tradition. This technique conveys the terror of the vampire cult led by the women of the household. In fact, the blood ritual of the cult is only broken up by intruding men who shoot Sugrobina dead before she can suck the blood out of the peasant woman. By contrast, Tolstoi's story ends with Runevskii waking from a nightmare to the news of the countess's passing overnight.

Sugrobina in red lens filter with red vampire eyes

Women are depicted in the film as cloistered and secretive, which maintains the viewer's suspicion of them. For instance, besides Dasha, who is an outcast of the family, and the servants, we almost never see women alone. They are shot sitting at round tables gossiping or giggling with other characters, giving side eyes to anyone that approaches them. The continuity shots between the other characters and Sugrobina emphasize her matriarchal hold over the household—she is the only woman allowed to be alone, and her face maintains a condescending smirk in day that gives way to a haunting glare at night, like she is possessed with two personalities. At nighttime, the director utilizes intellectual montage, splicing shots of moonlight and fast-pacing clouds with the nocturnal actions of characters, signifying both the passage of time and the characters' transition into unreality. A special red lens filter is reserved for the nightly meanderings of the head bloodsucker, Madame Sugrobina.

This film is truly one of the most horrific of the late Soviet cannon and it achieves this both through editing, minimal graphics, heighted affect, and by utilizing the trope of lustful women. Dasha, the sympathetic love of Runevskii and niece of

Sugrobina, best encapsulates the dichotomies between dream and reality, horror, and love. She is the spitting image of the deceased Praskovia Andreevna, the sister of Sugrobina's grandmother who supposedly died from the vampires. Throughout the film, as in the story, the viewer suspects that Dasha is in some way Andreevna reincarnated. In perhaps the most frightening scene of the film, Andreevna's spirit appears in Runevskii's room next to his bed. Her voice is like Dasha's, except the creators layered it with reverb and echo to convey a dream-like metaphysical feel. We know right away that something is unusual because the horrific leitmotif intensifies, but we only realize that it is the undead Andreevna when the camera shows her wide dead-pan eyes. Thus, the camera maintains our skepticism of Dasha, who would otherwise be the only woman that we want to trust, by making her likeness the first ghoul we see.

Dead-pan eyes of Praskovia Andreevna

Tatarskii's emphasis on men as the keepers of order and women

as suspect reinforces the social relation between men and women, who were, according to men, on the verge of taking their cravings and independence too far in late Soviet society. Indeed, it is barely a coincidence that this film came at a time of precarious women's liberation, when the freedoms of *perestroika* and *glasnost* gave way to a new outspokenness and consciousness among Soviet women. For example, in the late USSR, a major topic in official newspapers concerned the increase of children in orphanages who were abandoned by living parents. Most of those children could not be adopted precisely because their parents lived, contributing to a ballooning population of orphans around the country. People blamed "cuckoo" mothers for this unfortunate circumstance, as parental responsibility rested squarely on the mother deemed too selfish to care for their child.[19] In the film, Sugrobina is not a cuckoo mother, but she does chide respect for her own granddaughter Dasha in favor of another young relative, Sophie (Aleksandra Kolkunova). In her own self-interest, Sugrobina ignores her family to satiate her own bloodlust. Whereas the original story makes clear the responsibility of men for bringing the contagion into the family (or even making it up), the film places the blame and bloodlust squarely on women.

This chapter is not arguing that Tatarskii or Makarov were explicitly sexist, but it does posit that the creators were not blind to newspaper debates and discussions concerning women between 1987-1991.[20] For, even though the creators may not have purposefully sought to depict women as bloodsuckers, the fact is that the film appeared at a critical cultural moment in late Soviet society where women had a powerful voice. To take a well-known Marxist metaphor of socioeconomic leeches and apply it to women at this moment does suggest a level of myopia and disassociation from the plight of the working woman. By depicting the strong matriarchal Sugrobina as a literal *Upyr'*, and not leaving her status as such up for debate

as Tolstoi does, Tatarskii reified the image of a corrupt, morally bankrupt Russian woman for a new generation.

Conclusion

The Lycanthropy of Russia

The early 1990s in Russia are remembered as the hardest socioeconomic time in living memory, a second time of troubles even. Food and other consumer goods like cigarettes and flour were in short supply, nobody knew exactly what was happening to their children and the state and its accompanying services, institutions, and politicians. On top of the already traumatic AIDS pandemic, hard drug use became a common avenue for young adults looking to escape the struggles of sober life—or at least the state became more willing to publish its reported numbers. Then, just when things could not get any worse, millions of people woke up one morning with passports from a country that no longer existed. This time of troubles created an atmosphere of scarcity, where Russians turned to whatever self-preserving means they had to survive, relying on impulse and opportunity rather than state planning and paternalism.

In lieu of an isolated conclusion, this chapter presents two films that came out in 1991, officially recognized as the final year of the USSR: *Liumi, and Feofania risuiushchaia smert* (Feodania Painting Death, also known as The Clearing, and Time of Darkness). In many ways, these films provide a fitting conclusion in that they both deal with werewolves, or the idea of transformation. I am not the first to suggest a parallel between the lycanthropy and collapse: Viktor Pelevin, arguably Russia's most well-known post-Soviet writer, published a short story called "A Werewolf Problem in Central Russia" in 1991. As this chapter demonstrates, there's something about the werewolf's ability to both inhabit and transgress strict binaries that drew artists to the metaphor of amnesia-inducing transformation in the early 1990s. While Russia was officially transitioning from

a planned to a "market" economy, neither the path to get there nor the result were so sharply defined.

This conclusion uses the metaphor of the werewolf to study lycanthrope-centered films in the final year of the USSR. It argues that pop culture werewolves, just like their folkloric counterparts, appear during times of sociopolitical and economic distress to accentuate the push-and-pull between being and transforming, or condition and action. The chapter begins by briefly describing the context of early 90s Russian society—the transformations wrought by impending political and economic transition. Next, each movie is described, paying particular attention to their respective use of the werewolf figure. In the end, the two are linked to present the werewolf metaphor as a compelling way to understand the disappearance of the USSR. If the werewolf's human form embodies all the compounding problems of individual existence and experience, transformation offers a potential way to break free. As a conclusion, it suggests that the disappearance of the USSR and turn toward a market economy offered reprieve from the social, economic, and cultural issues addressed in previous chapters. Unfortunately, as we already know, the werewolf and the human share a singular consciousness and heart, meaning that transformation isn't always as perfect as its potential, and in fact can make things worse.

The Context

As mentioned in the previous chapters, beginning with *perestroika* and *glasnost*, Soviet society underwent a massive transformation of social relations and economic conditions. Nationalism, environmentalism, and consumerism all had enormous impacts on personal and public relationships across generational and cultural divides. In 1991, while most Soviet denizens supported a reformed Soviet Union, independence movements from the Baltic republics to the Caucuses gained enormous grounds in

their bid for independence. In February and March, Lithuania and Estonia held independence referendums that officially severed them from the Union of Soviet Socialist Republics. In June, Boris Yeltsin became Russia's first democratically elected president against Gorbachev's preferred candidate, Nikolai Ryzhkov. Finally, in August, Communist Party conservatives, who considered Gorbachev's decentralizing tendencies and the increasing calls for a market economy to save the Union to be anathema to lasting reform, orchestrated a coup attempt by putting Gorbachev under house arrest and banning all newspapers. The coup failed within days, but the consequences had already been deeply felt, and Yeltsin's bid for increased power only looked better. On August 24, Gorbachev resigned as general secretary, Ukraine declared independence, and 5 days later the Supreme Soviet suspended all Communist Party activity in Soviet territory. The revolution, up to this point, was at least on the surface non-violent, but the economic hardships felt by the average worker were anything but easy.

The reality is that even though the USSR collapsed with little to no official violence, the transition to a market economy rocked Russian society in the form of prolonged psychological and economic trauma. Part of the reason came from hyperinflation following the collapse of the planned economy. With that economic system in ruins, prices skyrocketed because goods no longer had government subsidies keeping prices down (except, it should be noted, in the military industry). Poultry, fish, flour, potatoes, and other staples of the Russian lifestyle went in short supply in cities like Moscow, Leningrad (Saint Petersburg), and Sverdlovsk and people looked for scapegoats in the mafia, the Communist Party, and foreign influencers. Leningrad's first mayor laid the blame for shortages of things like sunflower oil, salt, and matches on the "separatist" trends of people outside the central urban areas.[1] In Leningrad in particular, cigarette shortages led to riots in the summer of 1990. By 1991 one-

quarter of the Russian population spent their entire income on food alone, a testament to both the inflated value of the ruble, and the rising costs of goods.[2]

To rapidly ease the death pangs of Soviet socialism among the Russian people, Yeltsin proceeded with rapid market-oriented "shock therapy" pushed by both the United States and its powerful financial institution, the IMF. Extensive foreign investment meant that imports outnumbered exports, and the goods coming in were often too expensive for the heavily inflated Russian ruble. Whereas people with extra income turned to the second economy before and during *perestroika* for luxury items like audio equipment and clothing, rumors that food suppliers hoarded goods provoked increased volume in regular consumer goods outside of the regular economy. The black market, which had been such a sore for Gorbachev before 1991, increased in popular traffic due in large part to real and imagined regional protectionism and the unreliability of retail stores.[3] As a result, small producers sought to cut the state or private middleman from distribution.

All the economic hardship experienced by the Russian people meant that many of the issue-oriented social movements that emerged in *perestroika* disappeared or faded to the background. In the case of environmental politics, one notable observer guessed that many of the high-profile ecology advocates used environmentalism as little more than an opportunity to springboard their political careers.[4] With the secure supply of basic necessities in question, activism outside of direct personal economic interests became a progressively difficult occupation. In a fit of déjà vu, civil society temporarily checked out of politics, condemning the "rebirth of politics in Russia" to a hybrid state-neoliberal dictatorship.

Many scholars have written about the causes and consequences of collapse, with the focus understandably on 1991, the year when everything officially ended. Without

delving too much into the economic debates around the process, suffice it to summarize a few popularly accepted approaches. On the broadest level, William Moskoff points out that the Soviet economy disintegrated because once central planning was done away with, nothing was in place to fill the budgetary vacuum. The deficit remained, and the country could not service it without causing hyperinflation.[5] That explanation lacks agency, which Christopher Miller and Stephen Kotkin provide by arguing that politicians, who could not coordinate a response to economic turbulence caused primarily by increasing oil prices; the war in Afghanistan; and the arms race, created a catastrophic situation through sheer inertia.[6] The problem with this explanation is that the Kremlin remains the center of activity, leaving out the experiences of people on the ground in other cities who ultimately also had to acquiesce to collapse. Yet another interpretation argues that the leaders of the country did not consider the consequences of *perestroika* and therefore dug their own grave.[7] These arguments start to get at the idea that after 1986, a long-overdue process began to address lingering shortcomings in Soviet culture, society, and politics. And these are just the economic arguments: indeed, each of the issues outlined in previous chapters could also be used to explain how the second largest industrial power in the world lost its raison d'être between 1986-1991. Nationalism, generational differences, environmental degradation, and inequality all led Soviet citizens to feel indifferent to the state-socialist model, but not exactly socialism. Even in 1990, the vast majority of Russians (around 87 percent) still believed that the problem was not socialism, but the particular bureaucratic form it took in the USSR.[8]

What the lack of explanatory consensus suggests is a singular inescapable reality of the Soviet collapse; nobody, not even professional analysts nor academics, saw it coming the way it did. The plethora of explanations means, if anything, that

historians and onlookers continue to search for and ascribe a narrative explanation and a teleology to something that looks more zig-zag than linear. Like a werewolf on the morning after a full moon, it is only with hindsight that we can speculate what finally tore the Soviet body limb from limb, and the only sure thing is that transformation did happen. It was as though the Russian people woke up on the morning of December 25, 1991 to the final lowering of the Soviet flag over the Kremlin not entirely sure about why it was happening, what it meant, and what was going to happen to their clothes (or other goods). The reality of transition sent no direct signal to the now ex-Soviet people that economic hardship, generation strife, environmental degradation, or any other social problem would suddenly come to an end.

Concluding with the economic shortages in no way suggests that economics was the most important factor precipitating the collapse of the USSR. Instead, as I hope this book has made clear, several dynamics compounded each other in a mutually reinforcing system degrading the social fabric, political power, economic vitality, and cultural justification of the USSR. The introduction of the market economy and the privatization of state enterprises rested on the total transformation of homo Sovieticus into homo economicus, a narrowly self-interested consumer and producer hardened by the deprivation of the final years of Communism. It's in the context of that transformation that werewolf stories appeared in popular culture.

The Film(s)

Liumi is a horror comedy that uses the story of Little Red Riding Hood to comment on the intrusion of Western culture and economics into the very late Soviet Union. Not only is the story of Riding Hood popularly known to be German, but there's a scene in which the wolf-man finds a World War Two Era German helmet in the ground and puts it on as it terrorizes

the village, making the metaphor so obvious as to be parody. Interestingly, the story takes place in a small Lithuanian village, where a young girl, Marianna (Vita Grebneva), lives with her mother, Inga (Nadezhda Butyrtseva) and father, Ianis (Aleksandr Potanov). The family friend who dons the foreign last name Giumpert (Andrei Shcherbovich-Vecher) is an expert in the ethnography and story of Liumi, a wolf-man who can take human form whenever it wants. Giumpert, who is drawn to the story due to his own family's history (his great-grandfather killed the last known Liumi 100 years ago), has been tracking the beast throughout the Baltic region, hoping to get his book published by a foreign press.

At the beginning of the story, we see Giumpert in a car waiting for an individual to approach. A shady man walks up, and it becomes immediately clear that he is a black-market gun seller, and Giumpert is looking to purchase in preparation for his hunt of the Liumi. Believing everyone is in danger, Giumpert then urges Marianna to watch a televised special of him being interviewed about his book about the Liumi, which understandably frightens the little girl. When he arrives at the house after his television appearance, he warns the child with more details about the wolf-man, and arms her with mace, urging her to use it if the Liumi attacks.

Most of the film is a spectacular dark humor horror in which Giumpert tracks down the wolf-man and encounters a slew of characters along the way, including a wannabe police officer named Sigis (Aleksandr Mokhov) who tries to arrest him. At the end of the movie, as one can imagine, the Liumi takes the form of the girl's old Aunt Ester (Kapitolina Il'enko) but before it can swallow her up, she sprays the beast in the eyes, but accidently gets Giumpert as well. The antagonist and protagonist wrestle and it finally ends with Giumpert axing the wolf-man to death.

The film was the first and last by then young director and writer Vladimir Bragin.[9] Despite his novice status, he

demonstrated an amazing cinematographic ability, relying on both close-up fixations on facial expression, as well as tasteful camera angles that capture difficult aspects like the enormity of the wolf-man, little Marianna's perspective, and the goofiness of some of the characters. These techniques help convey the film's plot as a parody of Western horror cliches. In 1991, after a few years of Hollywood and other West European films flooding the Russian market, the recipe for horror made itself painfully obvious. Aiming to both reproduce and ridicule the genre, Bragin's story hijacks the formulaic elements and uses them for comedic relief. For instance, at the beginning of the film, the werewolf learns how to whistle an upbeat song that a truckdriver named "A Song About Rain." Veniamin Basner composed the song specifically for the film, but it is used as a parody of the traditional ominous musical leitmotif in horror. Not only is the melody not suspenseful, but the werewolf cannot remember it throughout the movie and whistles it differently each time. Thus, an essential element of the genre is trivialized or turned inauthentic.

Liumi is a comedy also in the sense that it uses obvious metaphors to demonstrate the absurdity of the transformations taking place in the period. Not only is the creature "not known by science" but Giumpert's entire expedition to expel the monster can be read as a witch hunt for "outsiders" or things that do not belong, whether it be German soldiers during World War Two, or objective, unscientific knowledge. There's a major social contradiction that Bragin is engaging with here: on the one hand, the foreigner is an entity that requires expulsion, but the main character realizes that his research is only as good as a foreign press is willing to print it. Officially, foreigners are suspect, but at the same time, to court foreign support means to somehow be more authentic. This paradox of authenticity is echoed in a key line uttered by Giumpert: "Liumi is strong because people don't believe in him." The obvious plot of the

Riding Hood story achieves both the authentic modernization of a classic folktale, and the exposure of the genre's ridiculous tropes. Toward the end of the film, we are forced to question whether Giumpert or the wolf-man are "more" authentic.

Feofania risuiushchaia smert is also a tale about pagans, witches, and werewolves but in a much more serious manner. Taking place in pagan Russia, before the widespread conversion to Christianity, the story follows the search for a murderer within a small village. On the night of the pagan god Perun's festival, a young woman is brutally raped and murdered. The pagan priest Gregory (George Segal) argues that only a werewolf could have mangled the girl's corpse to such a degree on the important night of celebration. The body is handed over to Feofania (Tamara Tana) who uses make up and other herbal concoctions to restore the dead woman's likeness in time for a funeral. Her amazing restorative skills instantly lead the villagers, including an annoying Orthodox Priest, Father Agafangel (Nikolai Kochegarov), to suspect Feofania of witchcraft. Eventually Feofania discovers who the real murderer is, but before she can out the villain publicly, she is condemned to death.

Feofania represents a middle path between pagan belief and Christianity. She is a strong, independent woman unbound by either religion, and thus suspicious of both. On the broadest possible scale, the film's narrative is a metaphor for split tensions between what was (paganism, communism) and what is becoming (Christianity, capitalism). The fact that both sides are depicted in their own evil light, with the camera frequently transfixed on the Priest's fanatic eyes, and George's dishonesty, means that director Vladimir Alenikov and writer Iuri Perov wanted to ground Feofania's moderation within her proximity to nature. She sculpts figures and gathers herbs, and as we see at the end of the film, her closeness with the natural world feeds an inner essence—her spirit is literally latched on to, or a part of, the physical environment. Like

the Grand Inquisitor in Dostoyevskii's Brothers Karamazov, Feofania suggests that even when the option of harmony and peace is presented to them, people cannot recognize it for what it is, and instead opt for self-sabotage. The werewolf in this case is a scapegoat for the villagers to explain away what they do not understand.

The representation of a "third way" speaks to the creation of the film as the first Russian-American collaboration. Alenikov understood that Western audiences had little to no interest in contemporary Soviet or Russian cinema, with its faded colors and muffled sound, and he endeavored to do something new. To retain control over production, and following a bad experience with his previous film, *Bindiuzhnik and the King*, Alenikov created an independent studio named Babylon. Using his new ability to dismiss state-run studios, who often did not even release films, Alenikov took advantage of the opening of free enterprise to seize his owns means of production and distribution. Thus, in many ways the film perfectly represents the transformation of the Russian film industry at the time and its piecemeal state: Odessa studios provided the set (an old village in the Moscow and Ryazan regions) and props, but it did not supply the film and equipment. Alenikov says he took advantage of his trip to the United States by recruiting the financial and technical support of an American studio, a feat unheard of before *perestroika*. At first, American companies flatly refused to work with an uninsured film company from the USSR, but then Kodiak offered to help with insurance and equipment under the condition that one of the main roles be played by an American (George Segal).[10] Hence, the film's very inception, while international in form, remained particularly Russian in content.

Lycanthropy

It's in some ways very fitting that werewolves should appear

in so many cultural platforms in the early 1990s. There are, of course, several interpretations of what werewolves symbolize, and they vary from place to place. One contemporary critic points out that werewolves connote raw emotion, impulse, and the wild—the opposite of vampires, their supernatural co-conspirators.[11] Carlo Ginzburg conducted a deeper study to try to understand the root of Europe's real historic relationship with werewolves. According to his research, they emerged across the various cultures of the continent from a common experience with ancient shamanism. The ecstasy experienced by a shaman, perhaps those with limited contact with the Roman world living in Siberia or present-day Eastern Europe, often used the imagery and symbology of wild animals.[12] These archaic recollections morphed over time into folk tales of humans transforming in the night to either work with the devil or fight against him.

However, while Ginzburg's theory captures the origin of a transcontinental connection character, werewolves came to represent different things depending on where you are in Europe. For example, at least one of our films takes place in the Baltics, where Willem de Blécourt argues there existed a unique werewolf tradition. Blécourt is dealing with the case of Thies of Kaltenbrun, who stated in 1691 before judges that he had the ability to turn into a wolf to fight off the devil and witches. He claimed to do so in a heroic effort to protect the harvest from the forces of evil, thereby suggesting that his lycanthropy was benevolent rather than nefarious.[13] Thies' case differs enormously from the 1589 German tale of Peter Stubbe, a bloodthirsty serial killer claimed to be in league with the devil.[14] In the first story, Thies was a hero who battled the forces of evil in the name of the village. In the second case, Stubbe was a ravenous murderer who achieved the werewolf title by contemporaries to explain his sadistic behavior. We are urged then to think of what lycanthropy means in the USSR by way of understanding not only these films, but their cultural resonance.

The Livonian werewolf is a decent place to start, because although it's not Russia proper, after hundreds of years of being ruled by Russians, there was plenty of cultural mixing to draw connections. Stefan Donecker opines that in Livonia, werewolf tales like Thies' emerged during times of trouble, especially among elites who needed to blame peasants for something.[15] The werewolf-as-scapegoat, similar to the witch, is a trope employed by the pagan priest Gregory in *Feofania risuiushchaia smert,* as he blamed the brutal murders on a werewolf stalking the village. In contradistinction, *Liumi* employs the more classical European version of a devilish fiend out to eat children. The Livonian werewolf is more fixated on the meaning and representation of the beast and its meanderings, and less concerned with the symbolism of the transformation. It therefore only captures one-half of the lycanthropic allegory.

Liumi wolf with German helmet

In Russia, werewolf stories are more directly concerned with the process of transformation. In Vologda province, a woman-

sorceress is said to have turned into a wolf by "throwing herself" over a rocker. In Smolensk, peasants recalled how the children of a sorcerer became wolves after drinking an elixir. In other regions the tale focuses on a witch mother-in-law that turns her stepchild into a werewolf.[16] In these tales, the transformation itself stands at the center of the narrative as a form of punishment. What all this implies, at least for the Soviet Union, are two related conjectures derived from the mixing of Russian and Livonian lycanthropy. On the one hand, Russian folklore focuses less on where the werewolf's loyalty lies (the devil or the divine) or what the broader symbolism of the being-in-itself represents, and more on the transformative process and its consequences. To be turned into a werewolf in Russian folk tradition is a lesson learned, and the tale ends there. On the other hand, the Livonian beast represents more specifically a scapegoat to explain times of unusual trouble; the actions of the werewolf are what matters most, not the transformation or punishment. We can therefore say that European USSR inherited two understandings of an already dualistic figure: one that is the obvious man and beast, and the other that focuses on condition and action.

This dual approach to the werewolf in Soviet culture is reflected in productions that emerged in the final days of the USSR, including Victor Pelevin's "A Werewolf Problem in Central Russia." In the story, Sasha encounters a pack of werewolves who transform him into one of their own and lead him to fight an older wolf. The narrator of the tale spends a lot of time detailing the sensations experienced by Sasha that are distinct from the human condition: a heightened sense of smell, hearing, and a faster-paced reality. To emphasize the transformative aspects more, Pelevin constantly refers to the human shapes rendered by wolf shadows and moonlight that work as a plot device to depict the unfamiliarity of transformation. Much like the Livonian were, in this story lycanthropy is heroic, creating

übermensches that rely on instinct rather than ideas or some pre-established plan. Sasha, is a symbol of improvement, existing more explicitly as a metaphor between the two choices facing Russians in late *perestroika*: reform or collapse, socialism or capitalism. Finally, Sasha's transformation as a "good" thing implies that only accepting change can initiate the path toward improvement, a naive presupposition considering that by the early 2000s, in *The Sacred Book of the Werewolf*, Pelevin's post-Socialist lycanthrope takes on its more demonic and deceitful rendition, indicating that the meaning of the metaphor changed.[17]

Like the Russian folktales, Pelevin's story also has an underlying moral element to it that deals with the circular transformations going on at the time. At the beginning of the tale, Sasha is confronted with a forked road, and he takes what he perceives to be the right path. However, after walking a while he realizes that he's completed a giant circle and goes the other way hoping to get to his destination. By the end of the tale, we learn that from the beginning he was manipulated into encountering the werewolf pack, implying that the cost of "freedom" is uniformity-through-individualism that differs from the path not taken, in which there is a millionaire collective farm in the village of Konkovo. In contrast to the blind conformity of the collective farm, "Soon the entire pack was howling. Sasha could understand the feelings expressed in every voice and the meaning of the whole business. Every voice howled its own theme..." Transformation heightened his perception of difference in action. Thus, the ability of the werewolves to remain free to express how they feel within a pack, an individualization through a collective activity becomes the new basis by which Sasha understands his condition.

Werewolves work within the binaries of human and unhuman, night and day, but they obliterate them by transgressing or reversing them. The werewolf is neither exclusively man nor

exclusively beast, and the human time of rest and slumber is when a werewolf is at its most active. These films, like Pelevin, pick up on this important aspect of the werewolf image and its liquidity in between what is too often considered a bipolar reality. The allegory of communism and capitalism is almost too simple, and such a dichotomy weighing on the minds of Russians gave way to a hybrid form of lived reality where scapegoats abound, and where the symbolism of lycanthropy as condition and action (being and transforming) re-emerged in another time of economic trouble. The difficult question remains, though, over which side of 1991 was human, and which was wolf, and whether transformation was more than skin deep.

Endnotes

Introduction

1. Linda Williams, "Film Bodies: Gender, Genre, and Excess," *Film Quarterly* 44, no.4 (Summer, 1991) 4.

2. Paul Wells, *The Horror Genre from Beelzebub to Blair Witch* (London: Wallflower, 2000) 9.

3. Fred Botting, *Gothic* (New York: Routledge, 1996) 90.

4. For homosexuality and horror read Harry Benshoff, *Monsters in the Closet: Homosexuality in the Horror Film* (Manchester: Manchester University Press, 1997).

5. Wells, *The Horror Genre*, 7.

6. S.S. Prawer, *Caligari's Children: The Film as Tale of Terror* (Oxford: Da Capo Press, 1989). Morris Dickstein, "The Aesthetics of Fright," in *Planks of Reason: Essays on the Horror Film*, ed. Barry Keith Grant (Metuchen: Scarecrow Press, 1984) 65-78.

7. Cyndy Hendershot, *I Was a Cold War Monster: Horror Films, Eroticism and the Cold War Imagination* (Bowling Green: Bowling Green State University Popular Press, 2001) particularly Chapter 4.

8. T. Underwood and C. Miller eds., *Kingdom of Fear: The World of Stephen King* (London: New English Library, 1986) 10.

9. Kendall R. Phillips, *Projected Fears: Horror Films and American Culture* (Westport: Praeger, 2005) 8.

10. Clifford Geertz, *The Interpretation of Cultures* (New York: Basic Books, 1973) 11.

11. In necrorealism, "traditional narrative elements are minimized in favor of an emphasis on the spectacle of necro-existence itself." Ellen E. Berry and Anesa Miller-Pogacar, "A Shock Therapy of the Social Consciousness: The Nature and Cultural Function of Russian Necrorealism," *Cultural Critique* 34 (Autumn, 1996) 188.

12. Aleksei Yurchak, *Everything Was Forever, Until it Was No More: The Last Soviet Generation* (Princeton: Princeton University Press, 2005) 246-248.
13. Jay Leyda, *Kino: A History of the Russian and Soviet Film* (Princeton: Princeton University Press, 1983) 74.
14. Leyda, *Kino*, 112-116.
15. Vance Kepley Jr., "Soviet Cinema and State Control: Lenin's Nationalization Decree Reconsidered," *Journal of Film and Video* 42, no. 2 (Summer 1990).
16. Leyda, *Kino*, 160.
17. Vance Kepley Jr., and Betty Kepley, "Foreign Films on Soviet Screens 1922-1931," *Quarterly Review of Film Studies* 4, no.4 (1979) 433.
18. Josephine Woll, "Exorcising the Devil: Russian Cinema and Horror" in Steven Jay Schneider and Tony Williams eds., *Horror International* (Detroit: Wayne State University Press, 2005) 344.
19. Iu. A. Rosina*, istoriia sovetskogo kino: uchebnoe posobie* (Ekaterinburg: Isdatel'stvo ural'skogo universiteta, 2019) 6-8.
20. Maron Chernenko, "Na kladbishche veter svishchet,' ili Amnistiia dlia vampirov," *iskusstvo kino* 8 (August 1992) 46.
21. E. A. Rusinova*, Istoriia kinootrasli v Rossii: upravlenie, kinoproizvodstvo, prokat* (Moscow, 2012) 1047-49.
22. Rusinova, *istoriia*, 1060.
23. Lev Nikulin, "No Horror in the Soviet Union?" NYU Jordan Center for the Advanced Study of Russian, 26 April, 2019, https://jordanrussiacenter.org/news/no-horror-in-the-soviet-union/#.YGXbaC2cZaE.
24. I. Maslennikov, "Kak del ana 'Lenfil'me," *Iskusstvo kino* no. 7, (1987) 7-8. One might notice my lack of reference to major journals like *Iskusstvo kino*, a major source of information on new blockbusters in the USSR. This is because the films that I discuss are not mentioned or are only passively mentioned

in their pages.

25. Chernenko, "'Na kladbishche veter svishchet'" 50.

Chapter 1

1. Natalya Chernyshova, *Soviet Consumer Culture in the Brezhnev Era* (London: Routledge, 2013) 6.

2. Jane Roj Zavisca, "Consumer Inequalities and regime legitimacy in late Soviet and post-Soviet Russia," PhD Diss., (University of California, Berkeley 2004) Ch. 2.

3. Chernyshova, *Soviet Consumer Culture,* 18.

4. Chernyshova, *Soviet Consumer Culture,* 30.

5. Lewis H. Siegelbaum, *Cars for Comrades: The Life of the Soviet Automobile* (Ithaca: Cornell University Press, 2008) 224-236.

6. James Millar, "The Little Deal: Brezhnev's Contribution to Acquisitive Socialism," *Slavic Review* 44, no. 4 (1985): 694-706.

7. Edwin Bacon and Mark Sandle, *Brezhnev Reconsidered* (New York: Palgrave Macmillan, 2002) 17.

8. Karl Marx, "Critique of the Gotha Program" in Robert C. Tucker trans., ed., *The Marx-Engels Reader* (New York: W.W. Norton, 1978) 531.

9. Chernyshova, *Soviet Consumer Culture,* 48.

10. A. Zdravomyslov, "Sotsial'naia sfera—aktual'nye problemy" *Kommunist* 16 (1981) 55.

11. Originally, Aleksandra Zavialova was supposed to play Pannochka, but she was replaced under the orders of Ivan Pyryev, who oversaw production, after she became involved with an American accused of espionage. The producers destroyed most of the footage with Zavialova, except for the scene when she is lying in her coffin by her father's side. TV Center "Vii. Tainy nashego kino" YouTube Video, 25:34 November 30, 2012, https://www.youtube.com/watch?v=ZgyCMR3Qe7Y.

12. Vitalii Dubogrei, "Kak iznachal'no dolzhen byl vygliadet'

Vii" *Livejournal*, October 9, 2019, https://dubikvit. livejournal.com/878230.html

Chapter 2

1. *Rabochii* 256 (22 November, 1933) 2, quoted in Ivan S. Lubachko, *Belarus Under Soviet Rule, 1917-1957* (Lexington: University of Kentucky Press, 1972) 114.
2. Lubachko, Belarus, 108-114; on World War Two, 165-167.
3. The trial of the Union for the Liberation of Ukraine, which received more attention than its Belarusian, Tatar, Crimean, and Uzbekistani corollaries. Terry Martin, *Affirmative Action Empire: Nations and Nationalism in the Soviet Union, 1923-1939* (Ithaca: Cornell University Press, 2001) 249.
4. *Bol'shevik* 10, (May 1945): 1-2. Quoted in Lubachko, *Belarus*, 171-172.
5. Tamara Lisitskaia, "'Dikaia okhota.' Byla li v pral'nosti istoriia is povesti Korotkevicha?" *Argumenty i fakty*, (November 11, 2020) https://aif.by/timefree/culture-news/ dikaya_ohota_byla_li_v_realnosti_istoriya_iz_povesti_kor otkevicha?fbclid=IwAR0z00qbRS4Eag27shk_2aT4PJ1KVho oBtUtgAARf-HGzyjX8ogH2Texs0s
6. Nadezhda Belokhvostik and Liudmila Selitskaia, "'Dikaia okhota korolia Stakha' Valerii Rubinchik: 'Kogda pisal stsenarii, drozhal ot strakha,'" *Komsomol'skaia Pravda*, 24 November, 2010, Accessed here: https://www.kp.by/ daily/24597.3/763913/
7. O. Kovalov, Eksperimentiruia v oblasti zhanrovykh struktur..." *Iskusstvo Kino* 9 (September, 1981) 54-64.
8. Belokhvostik, "Rezhisser kartiny."

Chapter 3

1. Karl Marx "Contribution to the Critique of Hegel's Philosophy of Right: Introduction" in Robert Tucker ed., *The Marx-Engels Reader* (W.W. Norton, 1978) 54.

2. Gregory Freeze, "From Dechristianization to Laicization: state, Church, and believers in Russia," *Canadian Slavonic Papers* 57, nos. 1-2 (2015) 7-11.

3. Gregory Freeze "The Religious Front: Militant Atheists and Militant Believers" in Keez Boterbloem, *Life in Stalin's Soviet Union* (New York: Bloomsbury, 2019) 209-223.

4. Felix Corley, *Religion in the Soviet Union: An Archival* Reader (New York: New York University Press, 1996) 184-185.

5. Sophie Kotzer, *Russian Orthodoxy, Nationalism and the Soviet State During the Gorbachev Years, 1985-1991* (London: Routledge, 2020) 7-8.

6. B. Ruinin, "Mirazh, muliazh i...epatazh," *iskusstvo kino* 11, (November, 1988) 54.

7. Elena Plakhova, "Peterburgskie fantazmy," *iskusstvo kino* 11, (November, 1988) 47.

8. It's worth pointing out that this is the same Sergei Kurekhin who became famous for his May 17, 1991 appearance on the TV show "5th Wheel," in which he presented a satirical theory that Lenin was a mushroom. Xox, "Sergei Kurekhin: Lenin was a mushroom" YouTube Video, 8:02, May 17, 2010, https://www.youtube.com/watch?v=h2cs8QLnxlU.

Chapter 4

1. Robert Peter Gale and Thomas Hauser, *Chernobyl: The Final Warning* (London: Hamish Hamilton, 1988) 165.

2. V. Mochalova, *Krokodil* 1, (January, 1987) Cover design.

3. Paul Josephson, Nicolai Dronin, et. al., *An Environmental History of Russia* (Cambridge: Cambridge University Press, 2013) 186-189.

4. Indeed, party leaders like Brezhnev looked to the example of Lenin's electrification campaign as inspiration. For more on that read Anne D. Rassweiler, *The Generation of Power: The History of Dneprostroi* (Oxford: Oxford University Press, 1988).

5. Christopher J. Ward, *Brezhnev's Folly: The Building of BAM and Late Soviet* Socialism (Pittsburgh: University of Pittsburgh Press, 2009) 9-10.
6. Paul Josephson, *Red Atom: Russia's Nuclear Power Program From Stalin to Today* (Pittsburgh: University of Pittsburgh Press, 2005) 244.
7. Geoffrey Hosking, *The Awakening of the Soviet Union* (Cambridge: Harvard University Press, 1990) 159.
8. Charles Tilly, "Models and Realities of Popular Collective Action," *Social Research* 52:4 (1985): 735-6.
9. Artemy Troitskii, *Back in the USSR: The True Story of Rock in Russia* (Boston: Faber and Faber, 1987) 15-19.
10. Gorbachev, M.S. "Doklad po plenume TsK KPSS: O perestroika i kadrovoi politike partii," *Izvestia*, (28 January, 1987) p.2.
11. Jim Gallagher, "Soviets blame hard tock for 'soft' youth," *Chicago Tribune,* November 1, 1981.
12. Josephine Woll, "Exorcising the Devil: Russian Cinema and Horror" in Steven Jay Schneider ed., *Horror International* (Wayne State University, 2005) 336.
13. V. Kamburov, "Vernem Leningradu more!" *Literaturnaia gazeta* no.44 (October 29, 2986).

Chapter 5

1. *Neformalny* refers to informal groups that sprang up during *perestroika*, many of them preservationist or environmentalist. Vera Tolz, "Informal Groups in the USSR," *The Washington Quarterly* 11, no. 2 (1988): 137-144.
2. Mikhail Gorbachev, *Perestroika: New Thinking for Our Country and the World* (New York: Harper and Row, 1987) 69.
3. William Moskoff, *Hard Times: Impoverishment and Protest in the Perestroika Years: The Soviet Union 1985-1991* (New York: M.E. Sharpe, 1993) 27-35.

4. Donald J. Raleigh, *Soviet Baby Boomers: An Oral History of Russia's Cold War Generation* (New York: Oxford University Press, 2012) 268-312.

5. Tolstoi originally wrote the story in German, but note the Russian translation is *Vurdalaka*, with an -a ending, translating to Vampire's Family. Vurdalakov, the film's rendition with the genitive -ov ending, is more accurately rendered Vampire Family (as in a family of vampires).

6. This point is well made in Irina Erman, "Nation and Vampiric Narration" in Aleksei Tolstoi's "The Family of the Vurdalak," *The Russian Review* 79 (January 2020): 9.

7. A number of reviews can be read here: https://www.kinopoisk.ru/film/255293/

8. "Kinoob"edinenie 'aist'" *Sovetskaia kul'tura* 12 May, 1990, pg. 7.

9. Gorbachev, *Perestroika*, 11. A highly recommended essay on the resurrection of Lenin in the waning years of the USSR is Aleksei Yurchak, "The canon and the mushroom: Lenin, sacredness, and Soviet collapse," *Journal of Ethnographic Theory* 7, no., 2 (Autumn 2017). Yurchak essentially argues that in their scramble to turn to Lenin to rescue them from ideological waterlog and provide guidance, experts realized they disagreed over what the "true" Lenin actually believed.

10. Alexander Herbert, *What About Tomorrow? An Oral History of Russian Punk from the Soviet Era to Pussy Riot* (Portland: Microcosm Publishing, 2019) 121.

11. Stephen Lovell, "Soviet Russia's Older Generations" in Stephen Lovell ed., *Generations in Twentieth-Century Europe* (New York: Palgrave Macmillan, 2007) 213, 222.

12. Paul Thompson and Victoria Semenova, "Family Models and Transgenerational Influences: Grandparents, Parents and Children in Moscow and Leningrad from the Soviet to the Market Era" in Leo Loenthal et al., eds *Living Through*

the Soviet System (New York: Taylor and Francis, 2017) 129.

13. Evegnii Iufit's necrorealist film "Papa, umer ded moroz" is a strange artistic take on Aleksei Tolstoi's story. However, I decided not to study this film because it purposely tries to avoid the conventions of modern cinema, and therefore doesn't fall under the same populist category that is fundamental to making claims about what it meant to late Soviet Russian society. For a fulfilling interpretation of the neo-realists, read Alexei Yurchak, *Everything was Forever, Until it Was No More: The Last Soviet Generation* (Princeton: Princeton University Press, 2005) 246-249.

Chapter 6

1. Karl Marx, *Capital Volume 1*, trans., Ben Fowkes (New York: Penguin, 1990) 342.

2. Karl Marx, "The Eighteenth Brumaire of Louis Bonaparte" in Robert C. Tucker trans., ed., *The Marx-Engels Reader* (New York: W.W. Norton, 1978) 611. Karl Marx, Grundrisse, trans., Ben Fowkes (New York: Penguin, 1973) 569.

3. Jason J. Morissette, "Marxferatu: The Vampire Metaphor as a Tool for Teaching Marx's Critique of Capitalism," *Political Science and Politics*, 46, no. 3 (July 2013): 637-642.

4. Mark Neocleous, "The Political Economy of the Dead: Marx's Vampires," *History of Political Thought* 24, no. 4 (Winter 2003): 673. And Matthew MacLellan "Marx's Vampires: An Althusserian Critique," *Rethinking Marxism* 25, no. 4 (2013): 550-552.

5. The hanging order is a letter sent to comrades in Penza, made famous by historian Robert Service. It can be found online here: https://www.loc.gov/exhibits/archives ad2kulak.html.

6. Dmitri Ivanov, "Chto pozadi?" *Ogonyok*, No. 32 (August, 1987): 22-25.

7. René Girard, *The Scapegoat*, trans., Yvonne Freccero (Johns

Hopkins University Press, 1989), 33. Jeffrey J. Cohen, "Monster Culture (Seven Theses)" in *Monster Theory: Reading Culture*, ed., Jeffrey J. Cohen (Minneapolis: University of Minnesota Press, 1996): 3-25.

8. Jules Zanger, "A Sympathetic Vibration: Dracula and the Jews," *English Literature in Transition 1880-1920* 34 no. 1 (1991): 33-45. Richard Dyer, "Children of the Night: Vampirism as Homosexuality, Homosexuality as Vampirism" in *Sweet Dreams: Sexuality, Gender and Popular Fiction*, ed., Susannah Radstone (London: Lawrence and Wishart, 1988). Also Harry Benshoff, Mark Jancovich, Eric Schaefer eds., *Monsters in the Closet: Homosexuality and the Horror Film* (Manchester: Manchester University Press, 1997).

9. Tony Throne, *Children of the Night: Of Vampires and Vampirism* (London: Orion Publishing Company, 2000): 43-46.

10. V.I. Lenin, "Speech at the First All-Russia Congress of Working Women on November 19, 1918" in *Lenin's Collected Works* (Moscow: Progress Publishers, 1974) 180-182.

11. Norma C. Noonan, "Does Consciousness Lead to Action? Exploring the impact of Perestroika and post-perestroika on women in Russia," *Journal of Gender Studies* 3, no. 1 (1994) 47-48.

12. Elizabeth Waters, "Restructuring the 'Woman Question': Perestroika and Prostitution," *Feminist Review*, Autumn 1989 no. 33 (Autumn, 1989) 6.

13. Mary Buckley ed., *Perestroika and Soviet Women* (Cambridge: Cambridge University Press, 1992) Introduction 1-6.

14. Evgeniii Tatarskii, *Zapiski kinorezhissëra o mnogikh i nemnogo o sebe*, (St Petersburg: BKhV-Petersburg, 2012) 224.

15. Svetlana Mazurova "Ne tak vazhen gonarar" *Rossiiskaia gazeta* September 2008, https://rg.ru/2008/09/10/ubiley.html

16. Evgeniii Tatarskii, "Zapiski kinorezhissera o mnogikh i nemnogo o sebe" ModernLib.net, Accessed 2021,

https://modernlib.net/books/Evgeniy_tatarskiy/zapiski
kinorezhissera_o_mnogih_i_nemnogo_o_sebe/read_1/

17. "'Delo' Artur Makarov (2000) fil'm-portret," YouTube video, 1:00:57, posted by "RVISION: Fil'my i serialy," February 14, 2018, https://www.youtube.com/watch?v=AI0gImKsMRE

18. A.A. Poliakova, O.V. Fedunina, "Goticheskaia traditsiia v proze A.K. Tolstogo ('Upyr')" *Mezhdunarodnyi kul'turnyi portal Eksperiment* April 12, 2019. https://md-eksperiment. org/post/20190413-goticheskaya-tradiciya-v-proze-a-k-tolstogo-upyr

19. Elizabeth Waters "'Cuckoo-mothers' and 'apparatchiks': glasnost and children's homes" in Buckley ed., *Perestroika and Soviet Women*, 129.

20. L. Kislinskaia, "'Legkoe povedenie' na vesakh pravosudiya," *Sovetskaia Rossiya*, 12 March, 2987 and N. Zenova, "Devochki v bare," *Literaturnaia gazeta* 47, 1985 are two examples of articles in major newspapers that comment on the fledging morals of women in Soviet society.

Conclusion

1. William Moskoff, *Hard Times: Impoverishment and Protest in the Perestroika Years, The Soviet Union 1985-1991* (New York: M.E. Sharpe, 1993) 34-35.

2. Moskoff, *Hard Times*, 43, 62.

3. Moskoff, *Hard Times*, 38-43.

4. O.N. Yanitsky, "Looking Back: Russian Environmental Movement in the late 1980s," *Research result, Social Studies and humanities* 2, no. 2, (2016) 63.

5. Moskoff, *Hard Times*, 15.

6. Christopher Miller, *The Struggle to Save the Soviet Union: Mikhail Gorbachev and the collapse of the USSR* (Chapel Hill: University of North Carolina Press, 2016) 148. Stephen Kotkin, *Armageddon Averted: The Soviet Collapse, 1970-2000* (Oxford: Oxford University Press, 2008) 3.

7. Victor Kuznetsov, "The Economic Factors of the USSR's Disintegration" in Anne de Tinguy ed., *The Fall of the Soviet Empire* (Boulder: East European Monographs, 1997) 264-279.

8. Moskoff, *Hard Times*, 22.

9. For reviews of *Liumi*, read https://www.kinopoisk.ru/film/45172/reviews/. Particularly Gelhi Ingvarsson and Irina15.

10. Mikhail Ermolovich, "Uzhasy v podmoskov'e" *Akvarium*, December 1990. Accessed June 1, 2021, http://alenikov.ru/stat.php?id_file=40.

11. Heather McCallum "The Werewolf/Vampire Dichotomy," In the Footsteps of Monsters, November 8, 2016 https://eportfolios.macaulay.cuny.edu/monsters/2016/11/08/the-werewolfvampire-dichotomy/.

12. Carlo Ginzburg, *Ecstasies: Deciphering the Witches' Sabbath* (Chicago: University of Chicago Press, 2004) 19, 154.

13. Willem de Blécourt, "A Journey to Hell: Reconsidering the Livonian 'Werewolf,'" *Magic, Ritual and Witchcraft* (Summer 2007) 63.

14. Matthew Beresford, *The White Devil: The Werewolf in European Culture* (London: Reaktion Books, 2013) 7-16.

15. Stefan Donecker, "The Werewolves of Livonia: Lycanthropy and Shape-Changing in Scholarly Texts 1550-1720," *Preternature: Critical and Historical Studies on the Preternatural* vol 1, no. 2 (2012) 312.

16. Marina Vlasova, *Russkie sueveriia* (Saint Petersburg: Azbuka, 2018) "Volkodlak."

17. E.A. Kulikova, "'Vervol'fy' V. Pelevina: genezis obraza chekoveka-volka" *Filologiia i chelovek* no. 3 (2013).

CULTURE, SOCIETY & POLITICS

Contemporary culture has eliminated the concept and public figure of the intellectual. A cretinous anti-intellectualism presides, cheer-led by hacks in the pay of multinational corporations who reassure their bored readers that there is no need to rouse themselves from their stupor. Zer0 Books knows that another kind of discourse - intellectual without being academic, popular without being populist - is not only possible: it is already flourishing. Zer0 is convinced that in the unthinking, blandly consensual culture in which we live, critical and engaged theoretical reflection is more important than ever before.

If you have enjoyed this book, why not tell other readers by posting a review on your preferred book site.

You may also wish to
subscribe to our Zer0 Books YouTube Channel.

Bestsellers from Zer0 Books include:

Give Them An Argument
Logic for the Left
Ben Burgis
Many serious leftists have learned to distrust talk of logic. This is
a serious mistake.
Paperback: 978-1-78904-210-8 ebook: 978-1-78904-211-5

Poor but Sexy
Culture Clashes in Europe East and West
Agata Pyzik
How the East stayed East and the West stayed West.
Paperback: 978-1-78099-394-2 ebook: 978-1-78099-395-9

An Anthropology of Nothing in Particular
Martin Demant Frederiksen
A journey into the social lives of meaninglessness.
Paperback: 978-1-78535-699-5 ebook: 978-1-78535-700-8

In the Dust of This Planet
Horror of Philosophy vol. 1
Eugene Thacker
In the first of a series of three books on the Horror of Philosophy,
In the Dust of This Planet offers the genre of horror as a way of
thinking about the unthinkable.
Paperback: 978-1-84694-676-9 ebook: 978-1-78099-010-1

The End of Oulipo?
An Attempt to Exhaust a Movement
Lauren Elkin, Veronica Esposito
Paperback: 978-1-78099-655-4 ebook: 978-1-78099-656-1

Capitalist Realism
Is There No Alternative?
Mark Fisher
An analysis of the ways in which capitalism has presented itself
as the only realistic political-economic system.
Paperback: 978-1-84694-317-1 ebook: 978-1-78099-734-6

Rebel Rebel
Chris O'Leary
David Bowie: every single song. Everything you want to know,
everything you didn't know.
Paperback: 978-1-78099-244-0 ebook: 978-1-78099-713-1

Kill All Normies
Angela Nagle
Online culture wars from 4chan and Tumblr to Trump.
Paperback: 978-1-78535-543-1 ebook: 978-1-78535-544-8

Cartographies of the Absolute
Alberto Toscano, Jeff Kinkle
An aesthetics of the economy for the twenty-first century.
Paperback: 978-1-78099-275-4 ebook: 978-1-78279-973-3

Malign Velocities
Accelerationism and Capitalism
Benjamin Noys
Long listed for the Bread and Roses Prize 2015, *Malign Velocities*
argues against the need for speed, tracking acceleration
as the symptom of the ongoing crises of capitalism.
Paperback: 978-1-78279-300-7 ebook: 978-1-78279-299-4

Meat Market
Female Flesh under Capitalism
Laurie Penny
A feminist dissection of women's bodies as the fleshy fulcrum of
capitalist cannibalism, whereby women are both consumers and
consumed.
Paperback: 978-1-84694-521-2 ebook: 978-1-84694-782-7

Babbling Corpse
Vaporwave and the Commodification of Ghosts
Grafton Tanner
Paperback: 978-1-78279-759-3 ebook: 978-1-78279-760-9

New Work New Culture
Work we want and a culture that strengthens us
Frithjof Bergmann
A serious alternative for mankind and the planet.
Paperback: 978-1-78904-064-7 ebook: 978-1-78904-065-4

Romeo and Juliet in Palestine
Teaching Under Occupation
Tom Sperlinger
Life in the West Bank, the nature of pedagogy and the role of a
university under occupation.
Paperback: 978-1-78279-637-4 ebook: 978-1-78279-636-7

Color, Facture, Art and Design
Iona Singh
This materialist definition of fine-art develops guidelines for
architecture, design, cultural-studies and ultimately social
change.
Paperback: 978-1-78099-629-5 ebook: 978-1-78099-630-1

Neglected or Misunderstood
The Radical Feminism of Shulamith Firestone
Victoria Margree
An interrogation of issues surrounding gender, biology,
sexuality, work and technology, and the ways in which our
imaginations continue to be in thrall to ideologies of maternity
and the nuclear family.
Paperback: 978-1-78535-539-4 ebook: 978-1-78535-540-0

How to Dismantle the NHS in 10 Easy Steps (Second Edition)
Youssef El-Gingihy
The story of how your NHS was sold off and why you will have
to buy private health insurance soon. A new expanded second
edition with chapters on junior doctors' strikes and government
blueprints for US-style healthcare.
Paperback: 978-1-78904-178-1 ebook: 978-1-78904-179-8

Digesting Recipes
The Art of Culinary Notation
Susannah Worth
A recipe is an instruction, the imperative tone of the expert, but
this constraint can offer its own kind of potential. A recipe need
not be a domestic trap but might instead offer escape – something
to fantasise about or aspire to.
Paperback: 978-1-78279-860-6 ebook: 978-1-78279-859-0

Most titles are published in paperback and as an ebook.
Paperbacks are available in traditional bookshops. Both print and
ebook formats are available online.
Follow us at:
https://www.facebook.com/ZeroBooks
https://twitter.com/Zer0Books
https://www.instagram.com/zero.books